AMAZING FLORAL DESIGNS

48 Images to Adorn with Color

KATHY G. AHRENS

Racehorse Publishing

Racehorse Publishing books may be purchased in bulk at special discounts for sales promotion, corporate gifts, fund-raising, or educational purposes. Special editions can also be created to specifications. For details, contact the Special Sales Department, Skyhorse Publishing, 307 West 36th Street, 11th Floor, New York, NY 10018 or info@skyhorsepublishing.com.

Racehorse Publishing™ is a pending trademark of Skyhorse Publishing, Inc.®, a Delaware corporation.

Visit our website at www.skyhorsepublishing.com.

10 9 8 7 6 5 4 3 2 1

Cover design by Michael Short
Cover and interior artwork: Kathy G. Ahrens

Print ISBN: 978-1-944686-81-9

Printed in the United States of America

INTRODUCTION

Coloring is a wonderful meditative exercise that relieves stress and encourages focus. Recall the hours you spent as a child with your beloved crayons and markers, creating masterpieces from nothing but the whims of your imagination. As adults, we often forget that we, too, can still enjoy such simplicities. With this coloring book, you can do just that. Take a moment from your busy day and enjoy a moment of serenity.

Proven to be beneficial for brain development and maturation, coloring is a healthy and productive way to de-stress. We find that, while coloring itself is beneficial, what you choose to color is important as well. The graceful and intricate lines in the following designs recommend themselves to meditation and relaxation. In the pages of this coloring book, you'll find an assortment of beautiful florals to fill with your favorite tones.

As you color, imagine yourself stretching and folding into the creases of the patterns; let your imagination flow through the colors as you envision the endless possibilities for these designs. Focusing on an activity beyond your usual routine will exercise your mind while diverting it from its usual stressors. Find a quiet place or put on headphones with some relaxing music, and explore your consciousness.

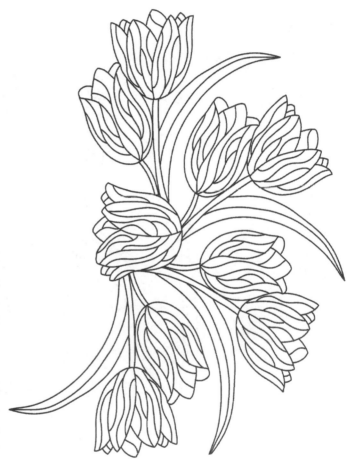

Forty-eight entrancing black-and-white designs are included in the following pages, awaiting your imaginative palette. The pages are perforated, so you can remove them for more convenient coloring and display your art when you're finished. At the back of the book, you'll find palette bars with which you can test your medium and plan your color combinations if you wish. Whether you're taking a Zen moment from the work day or slowing down on the weekend, this coloring book will provide you with hours of soothing relaxation.

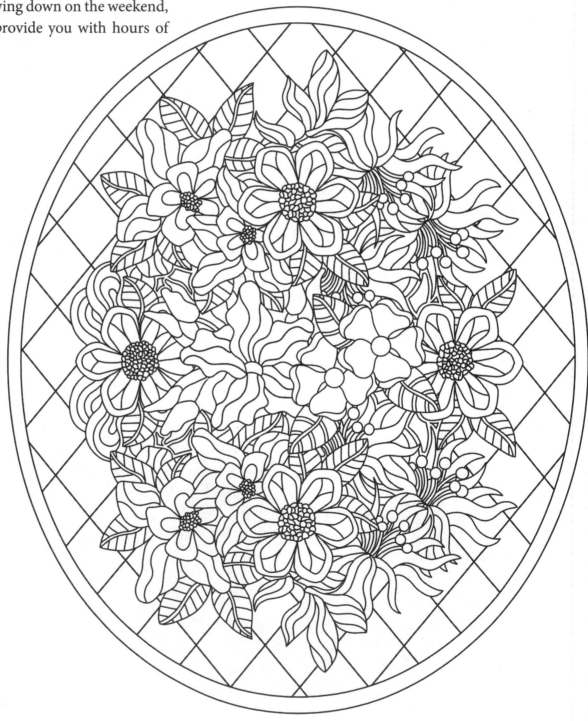

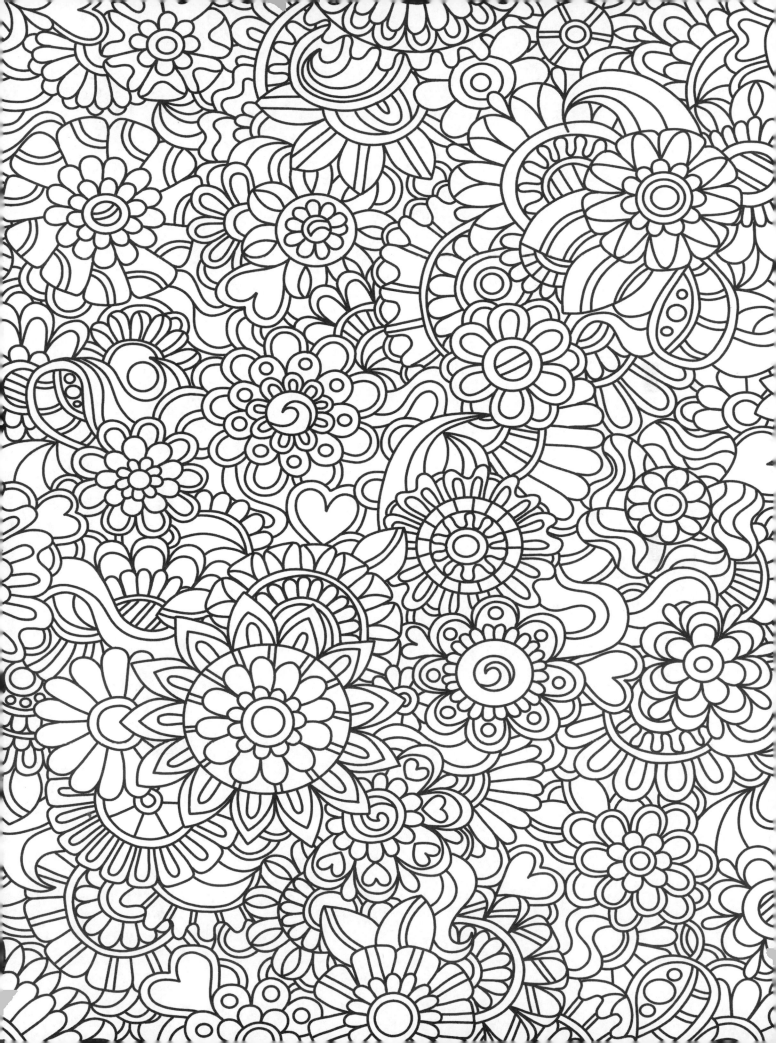

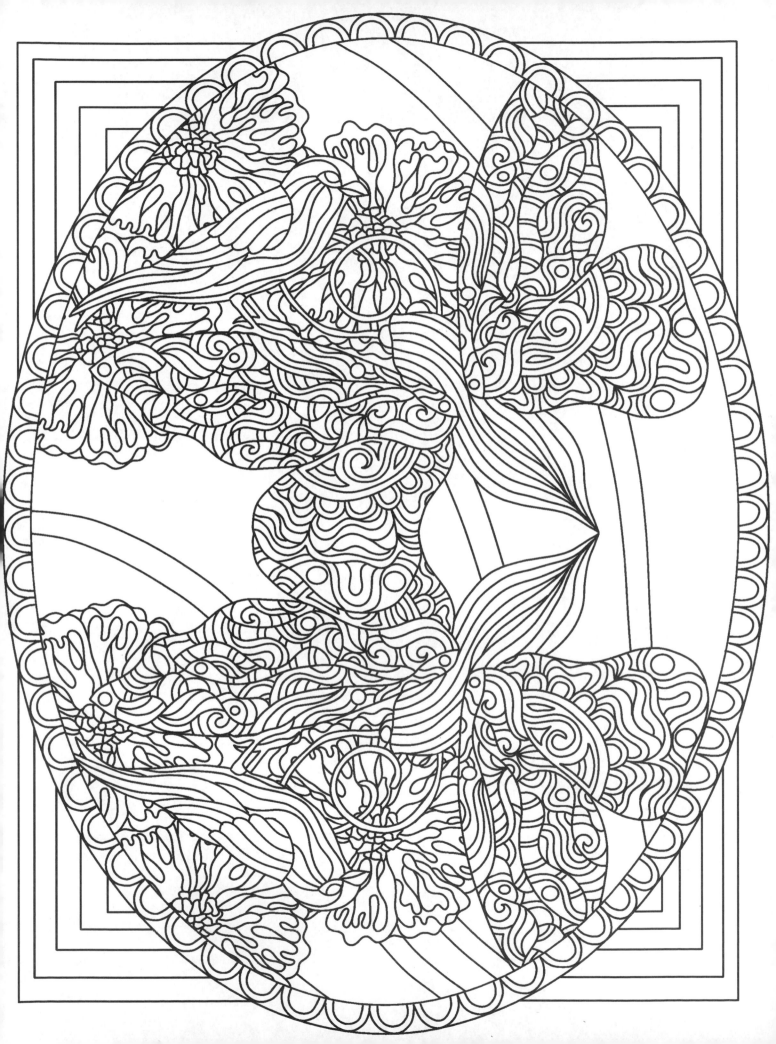

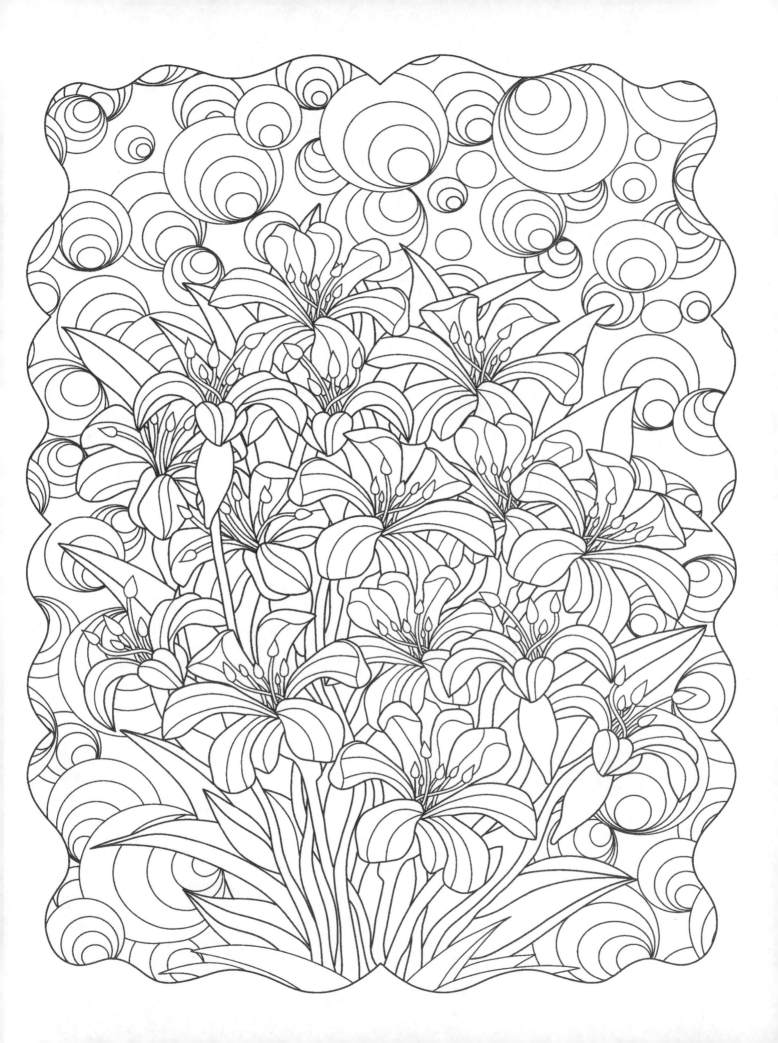

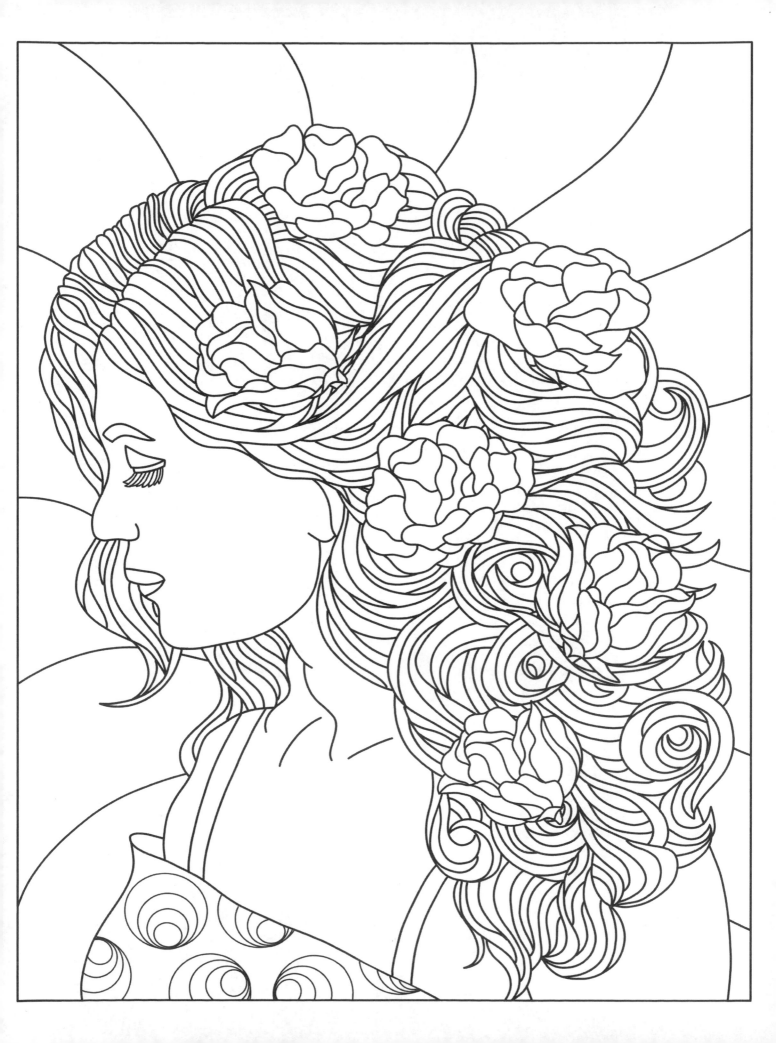

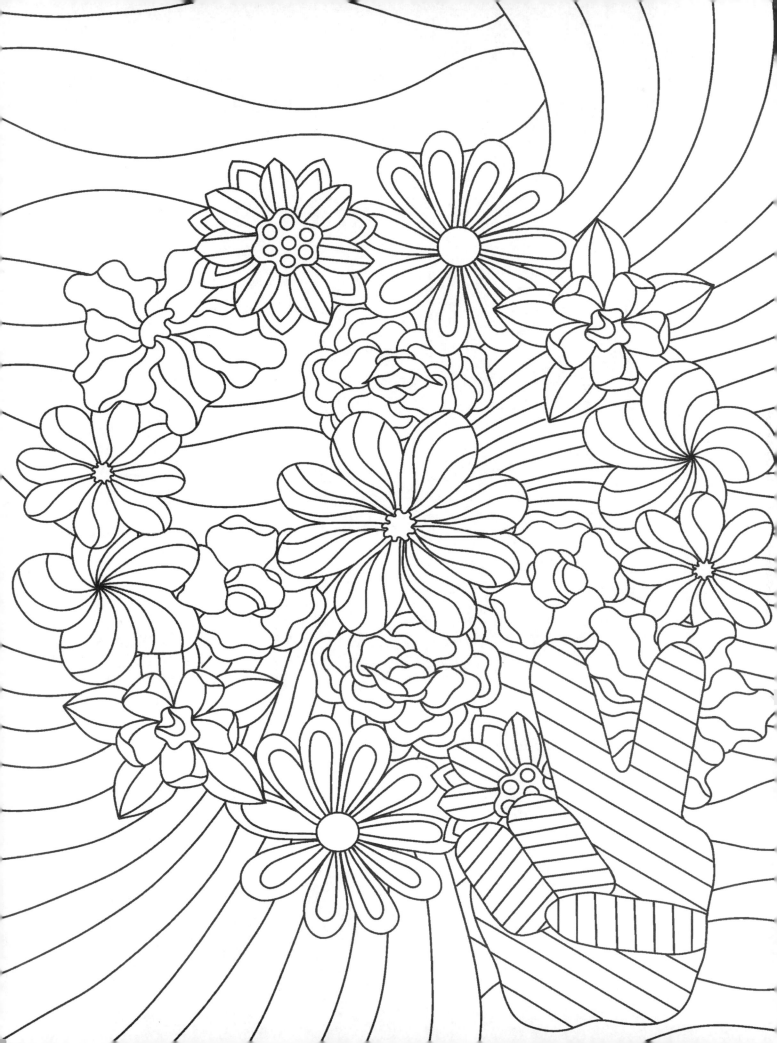

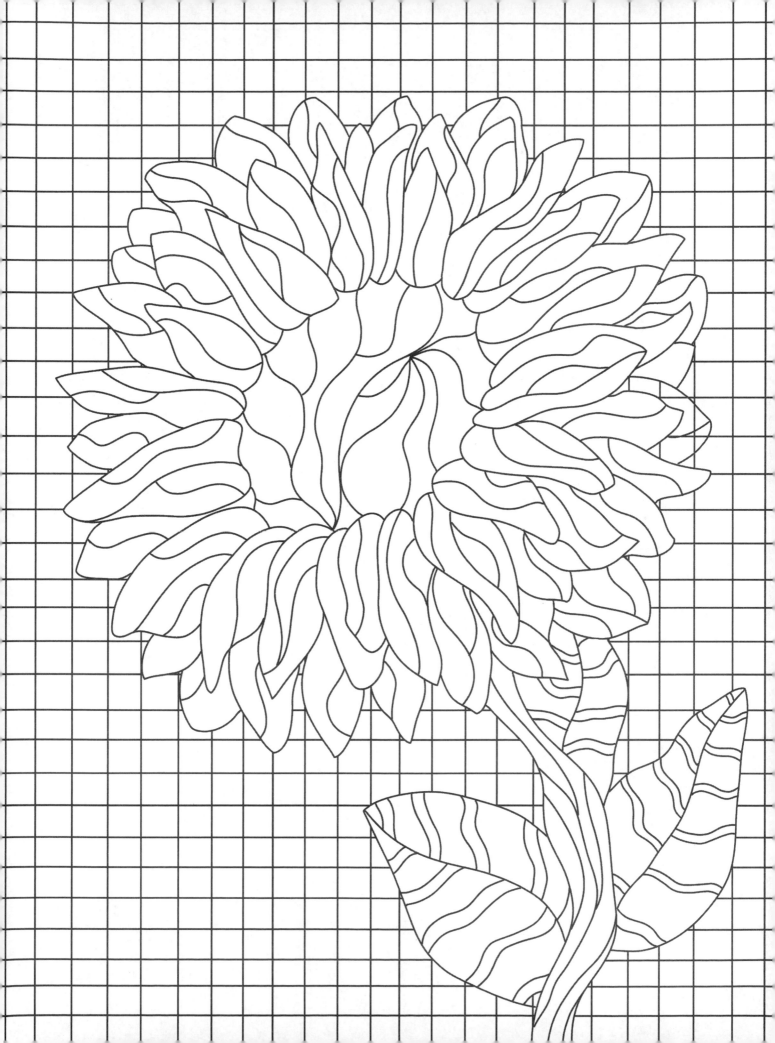

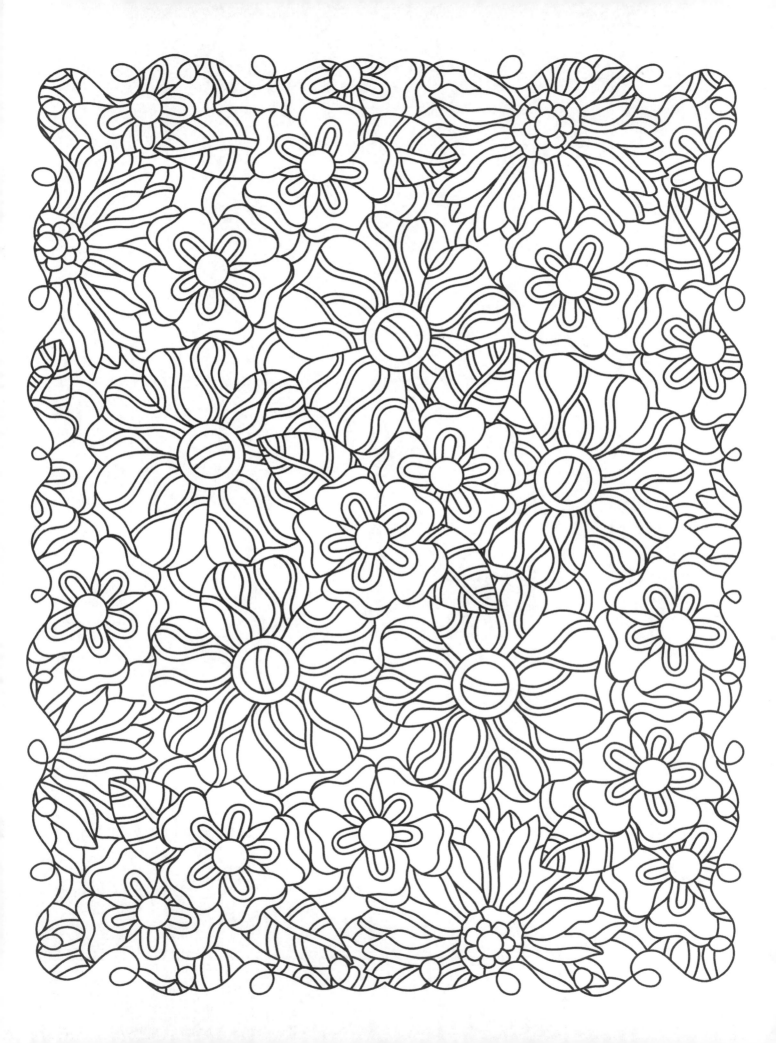

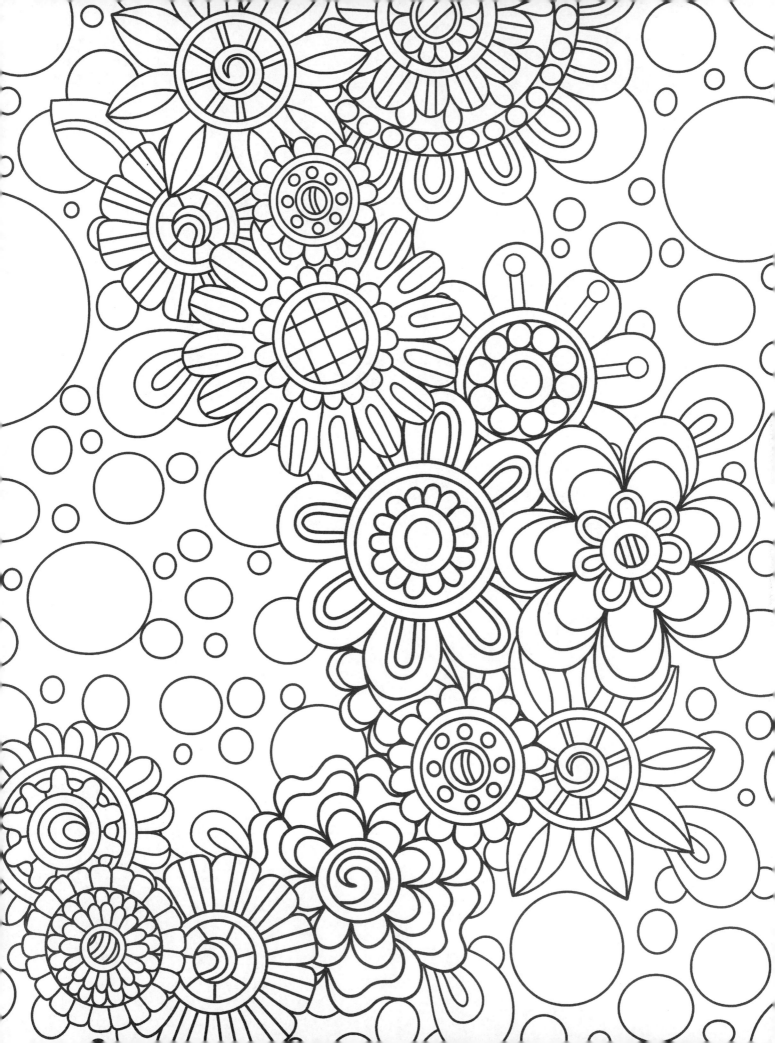

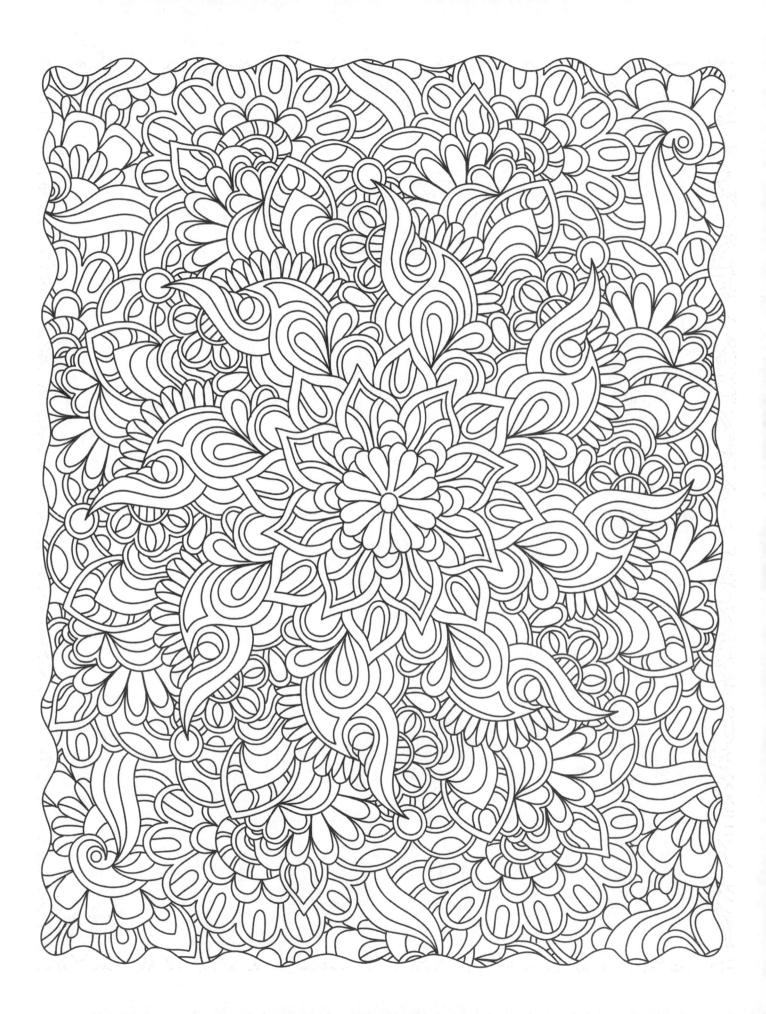

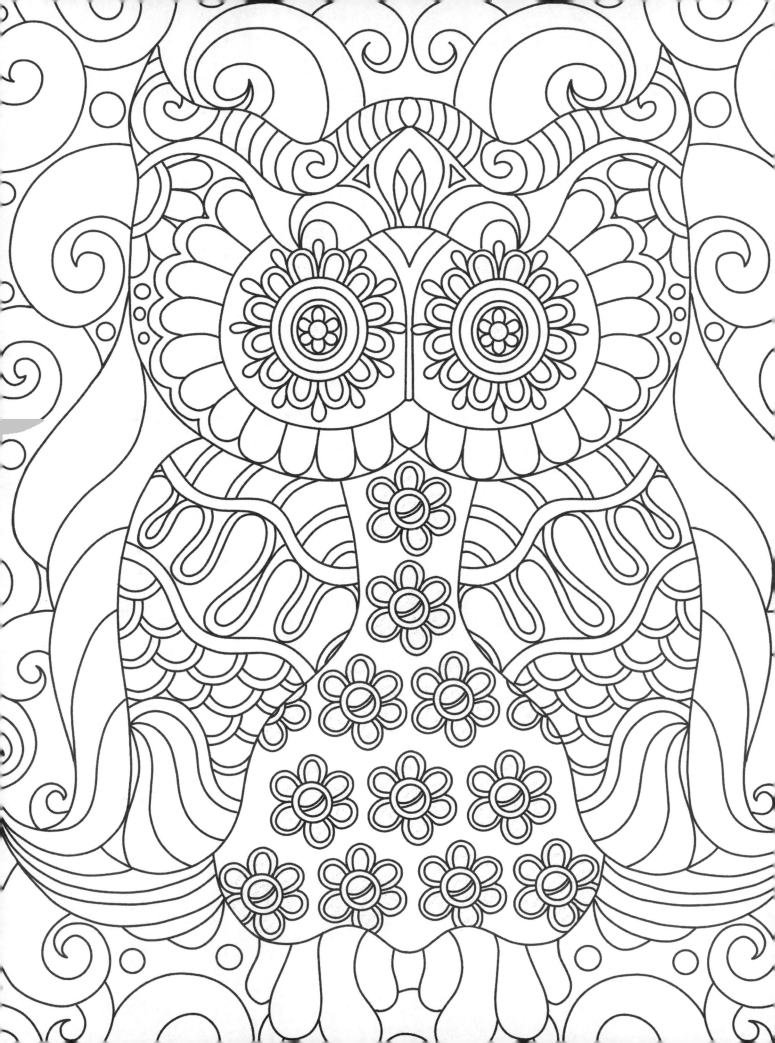

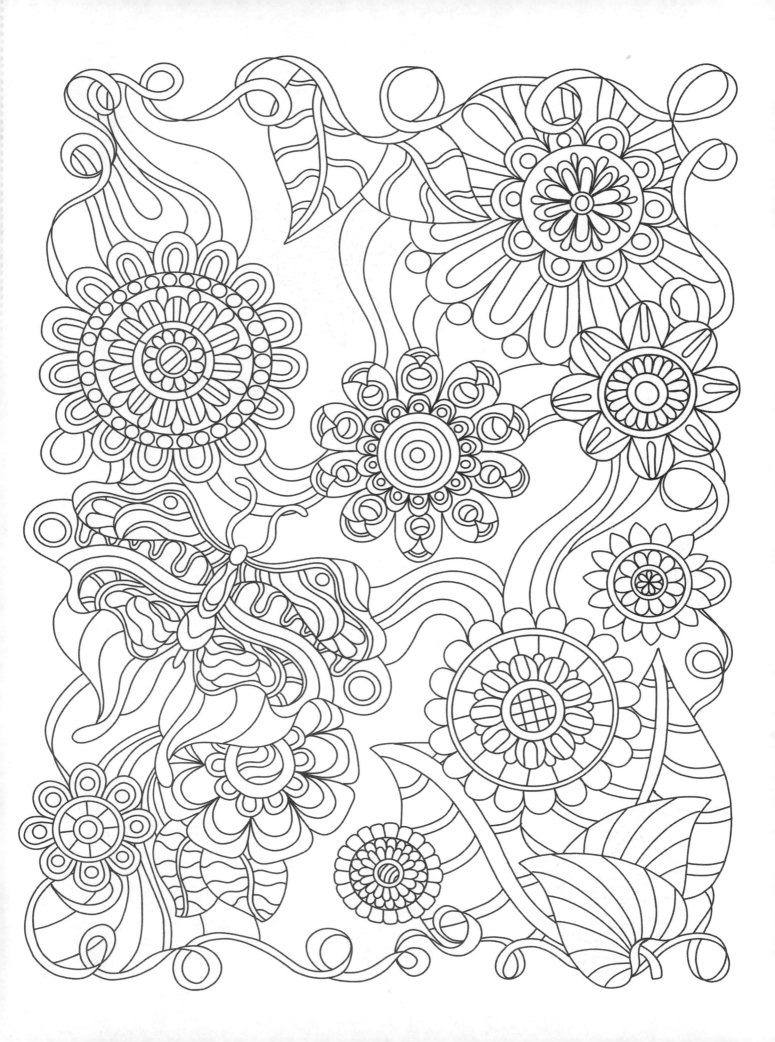

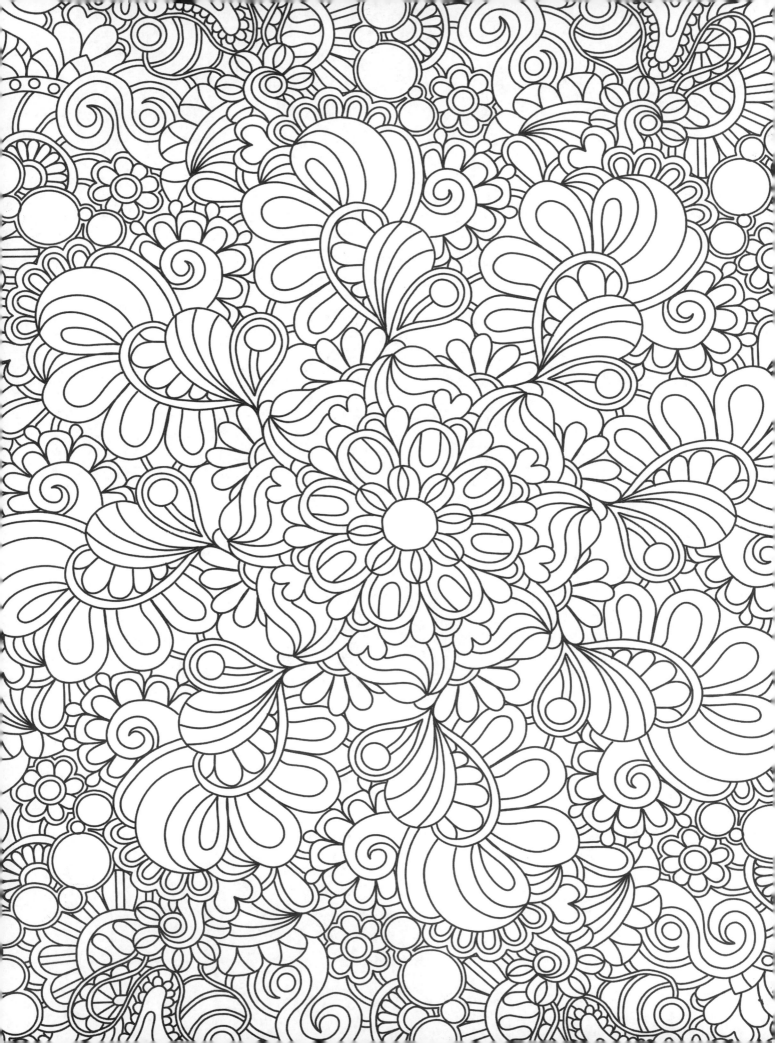

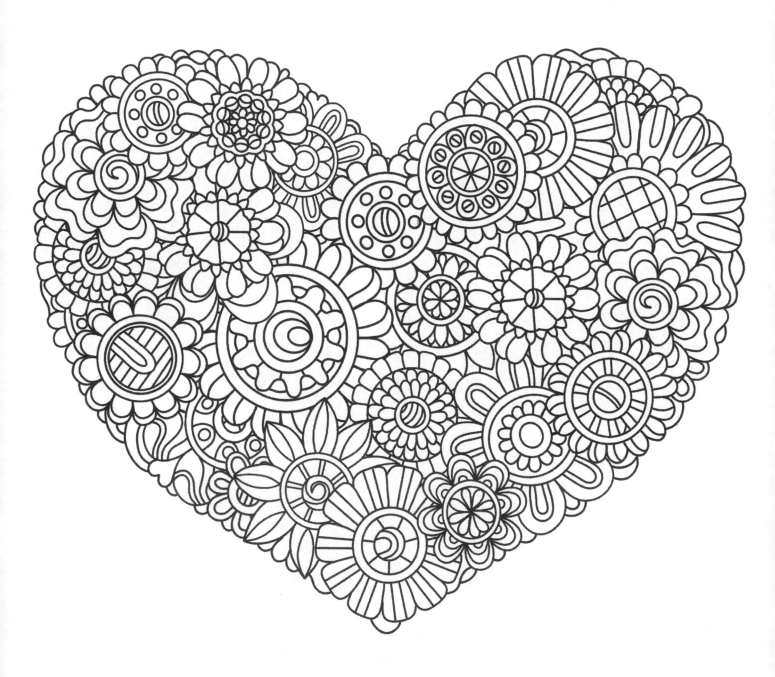

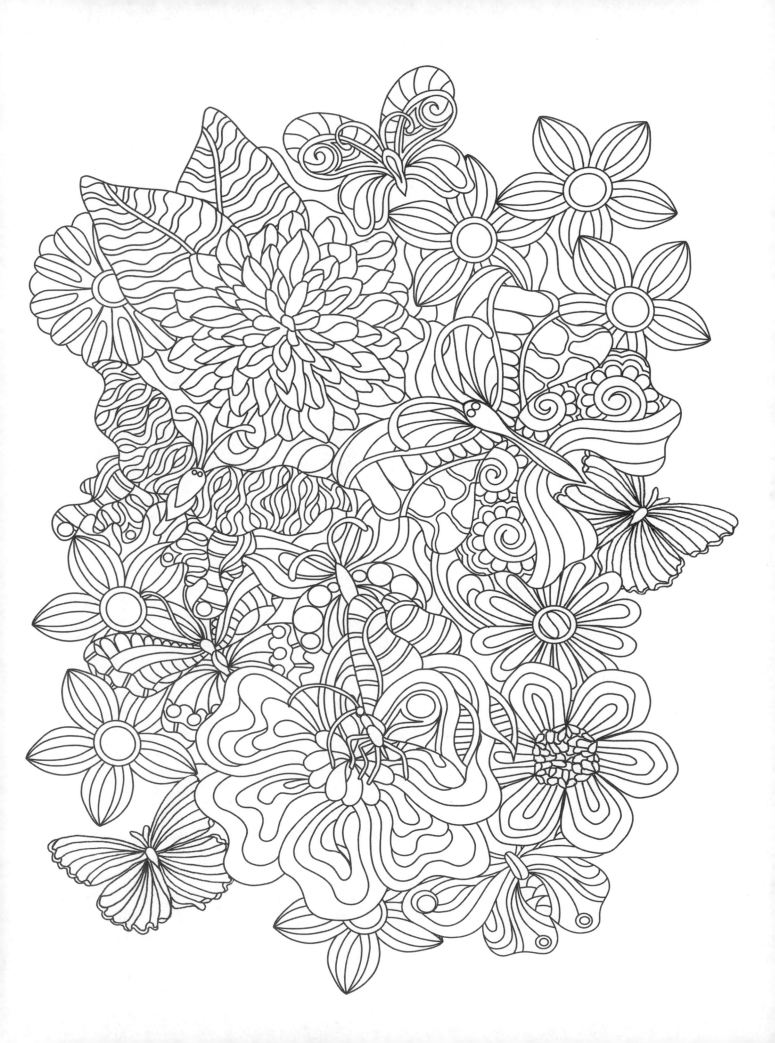

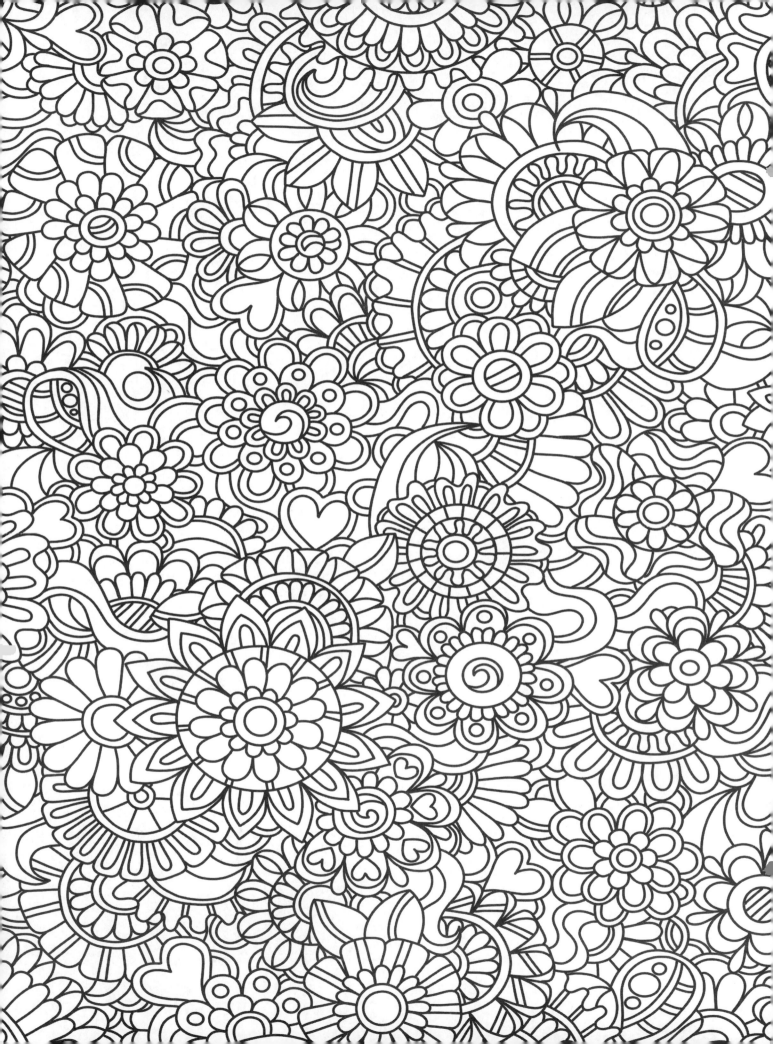

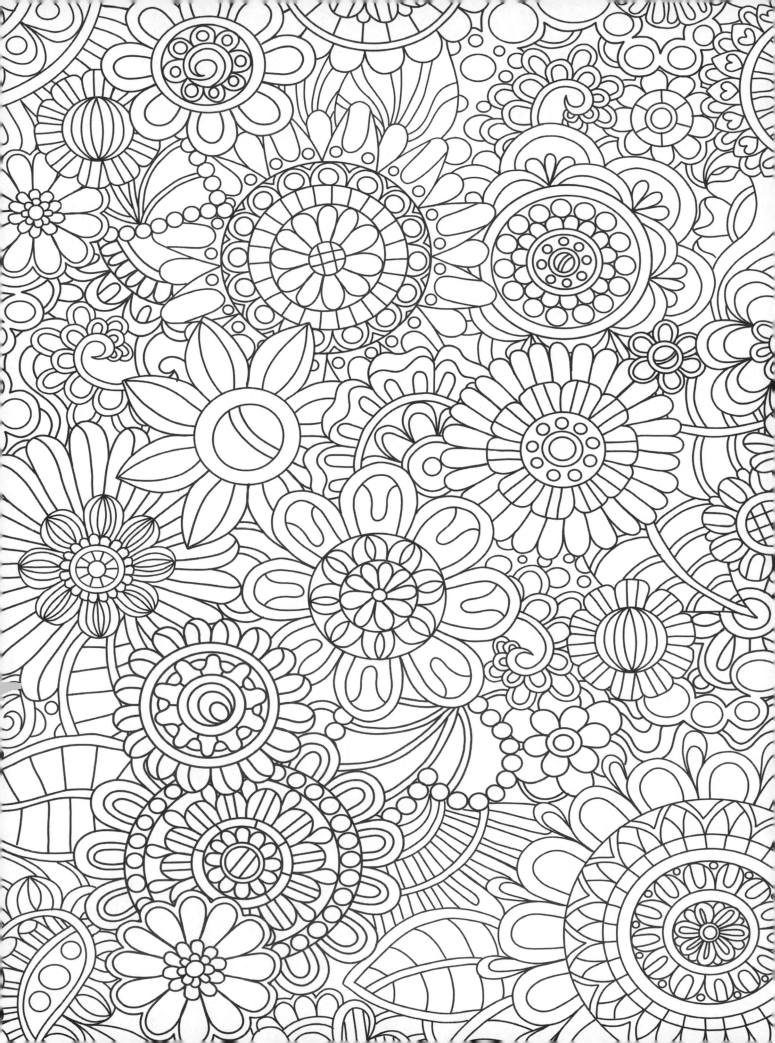

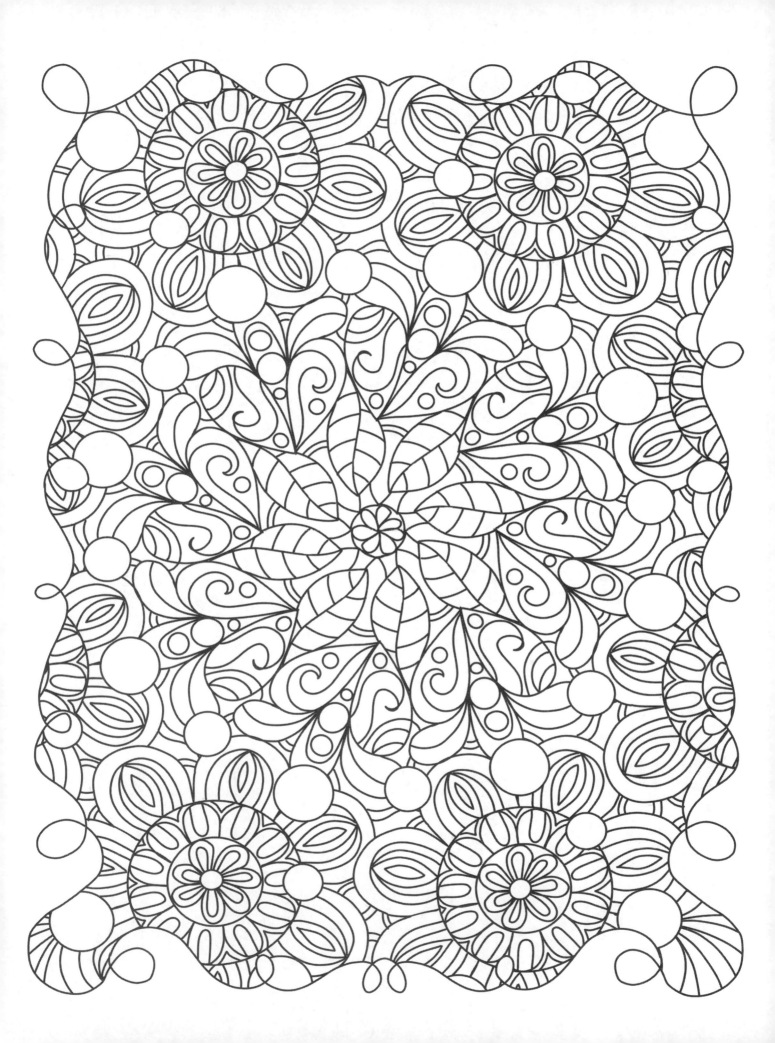

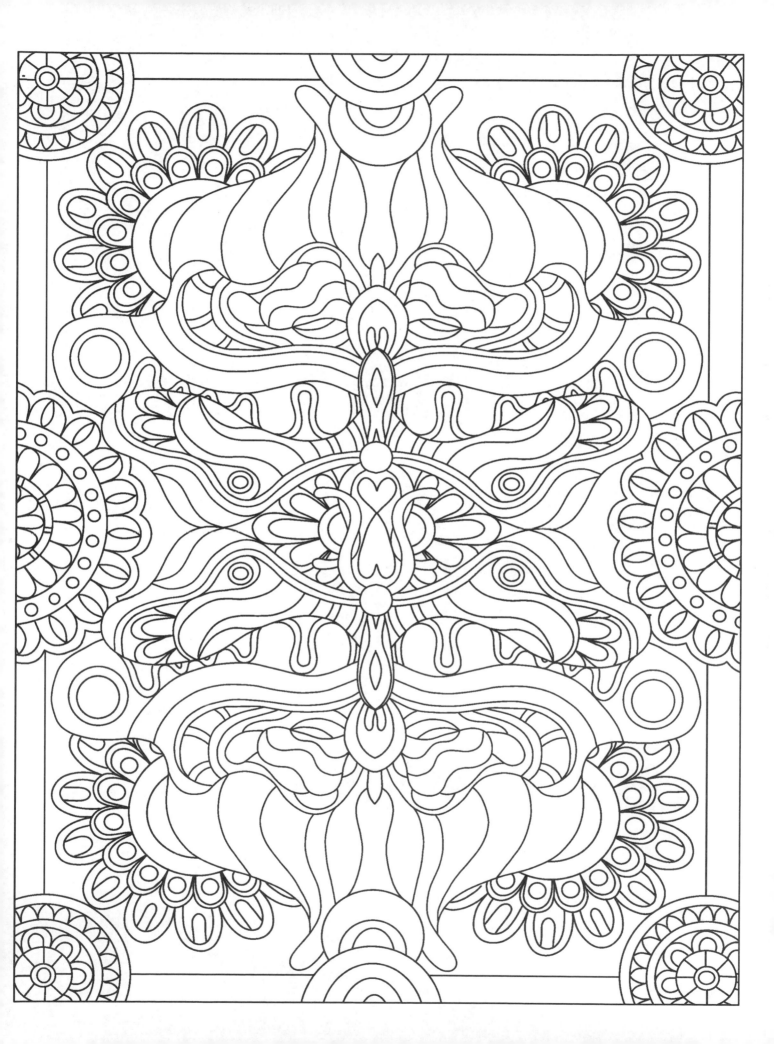

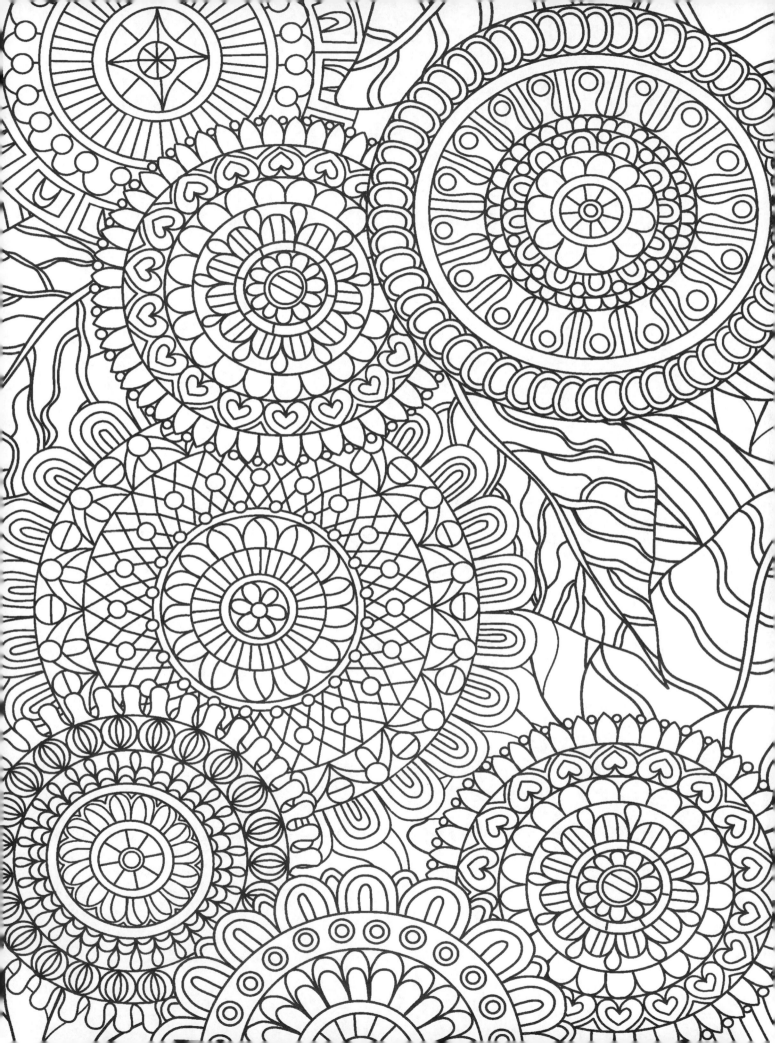

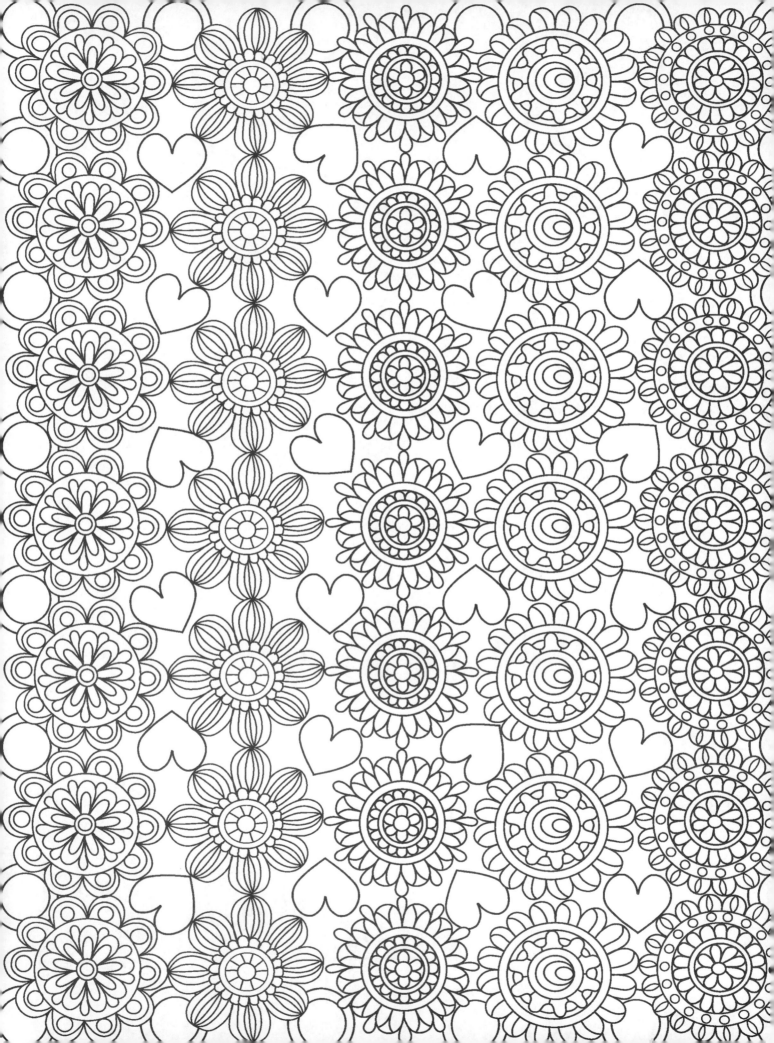

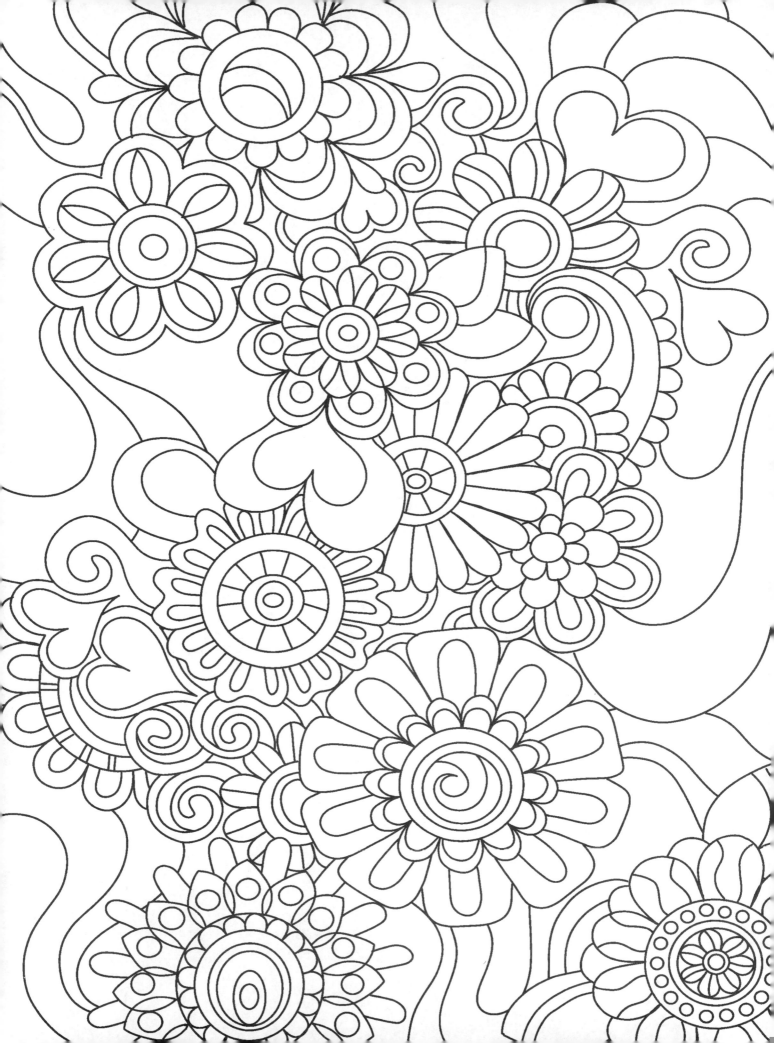

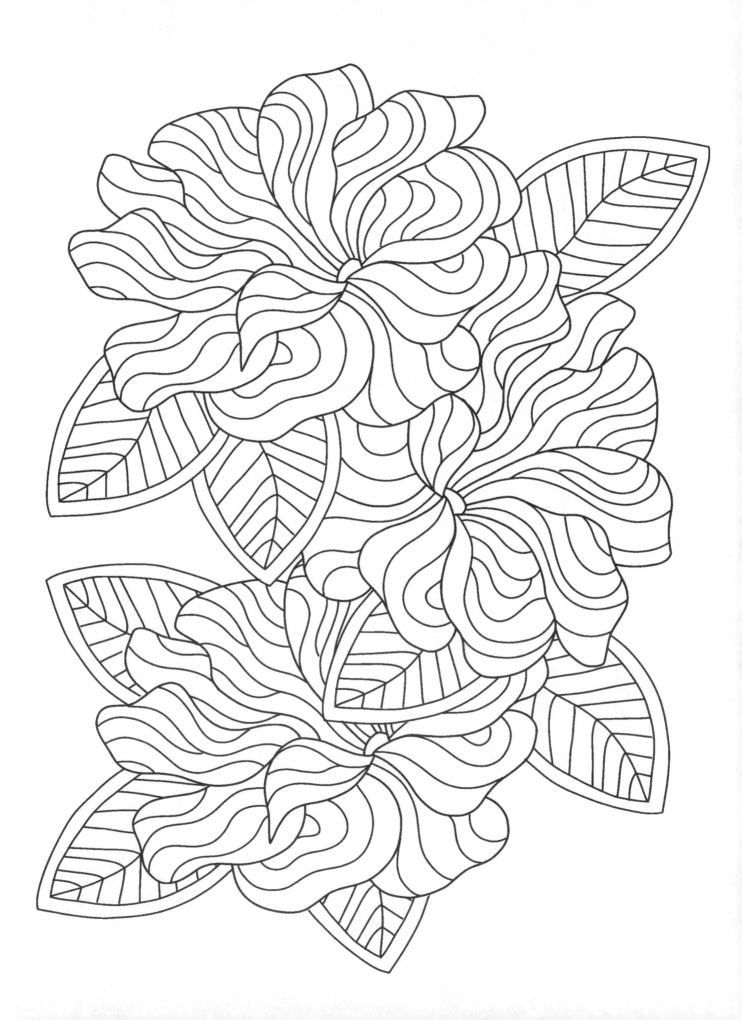

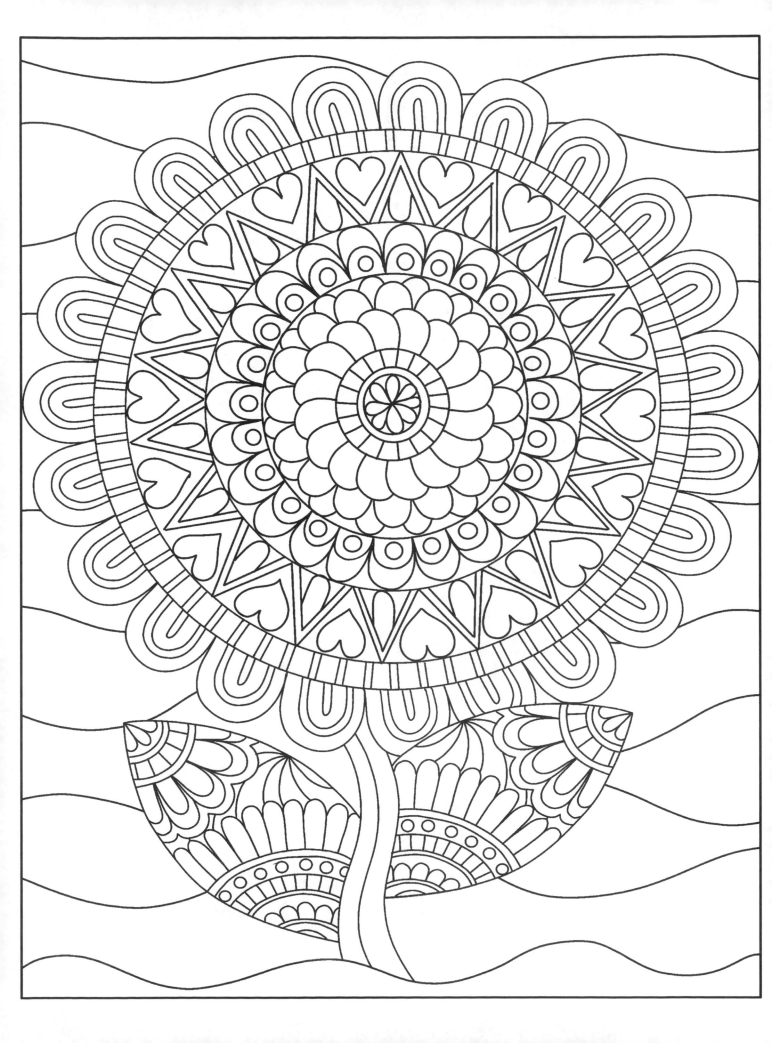

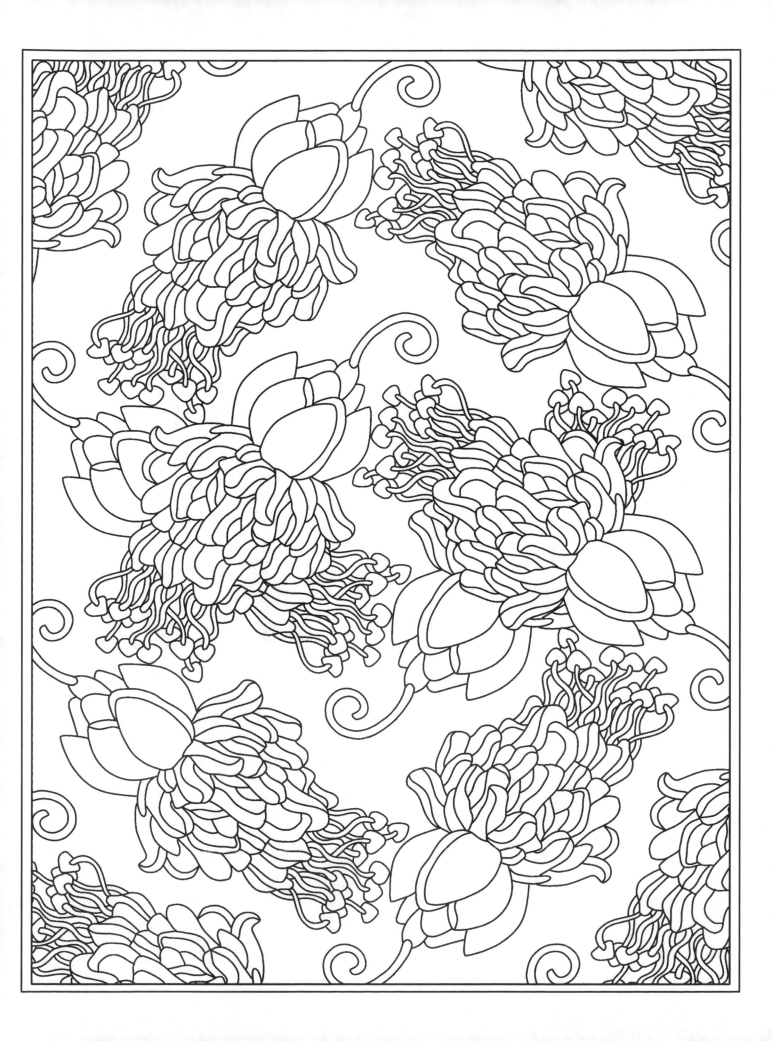

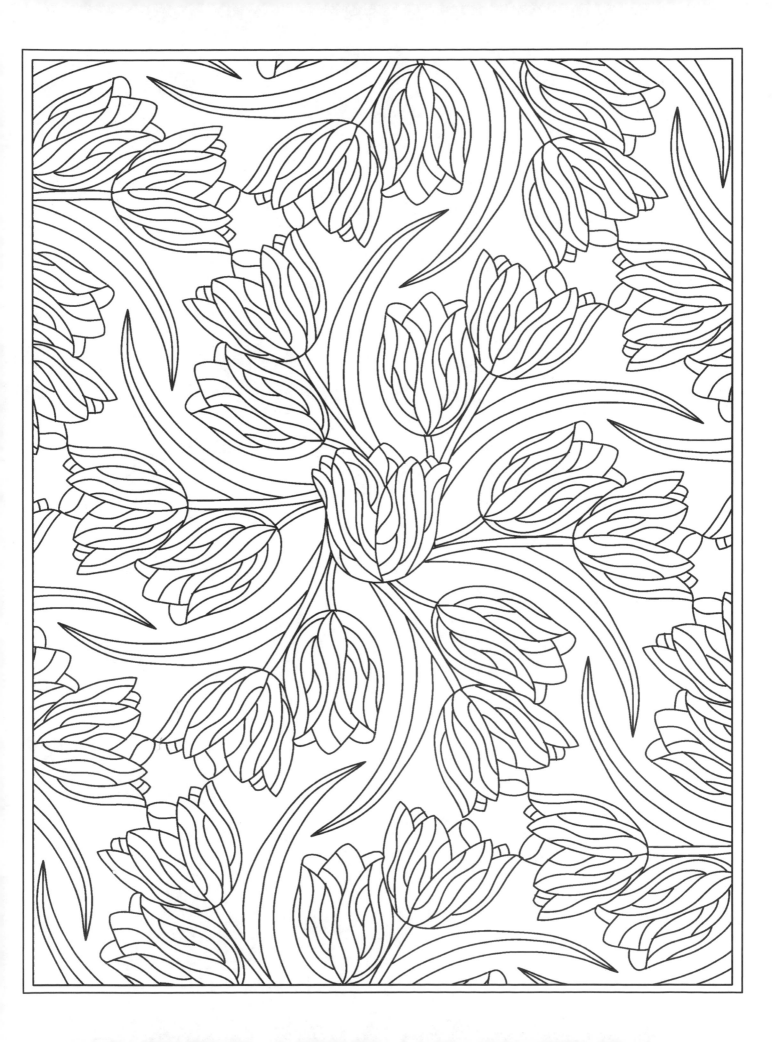

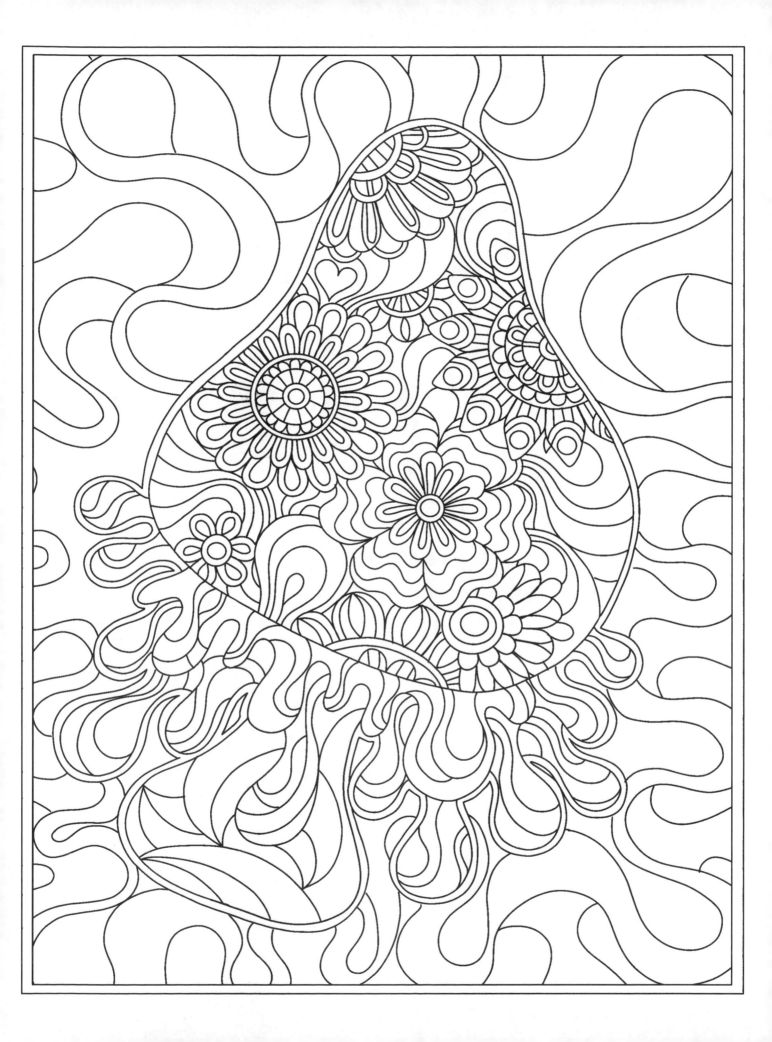

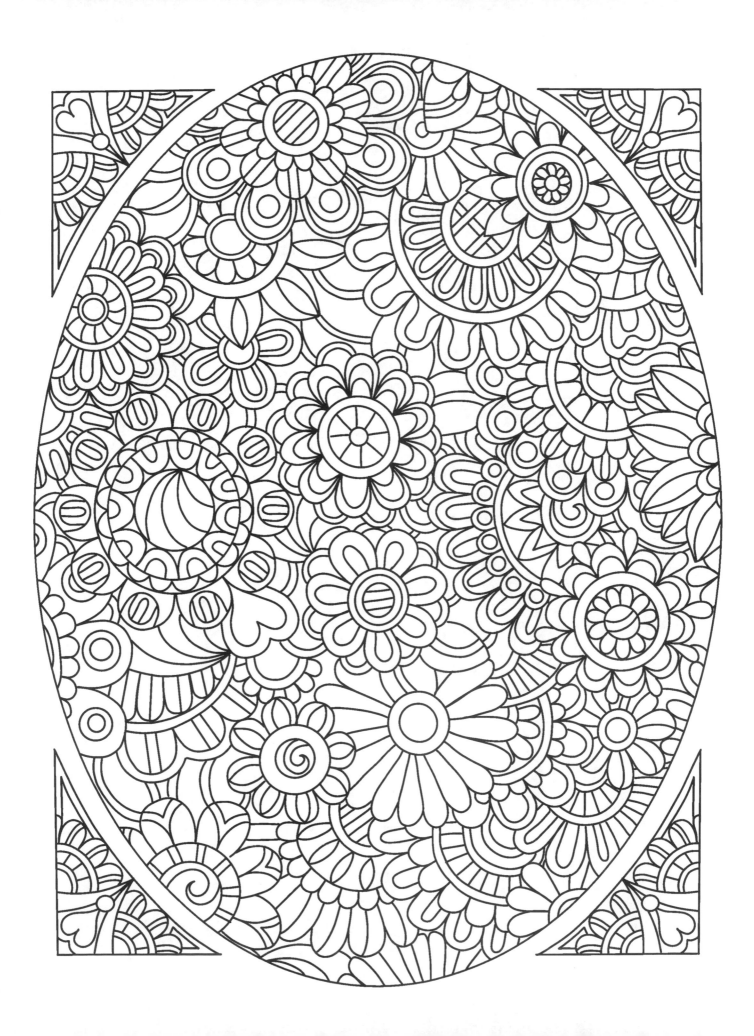

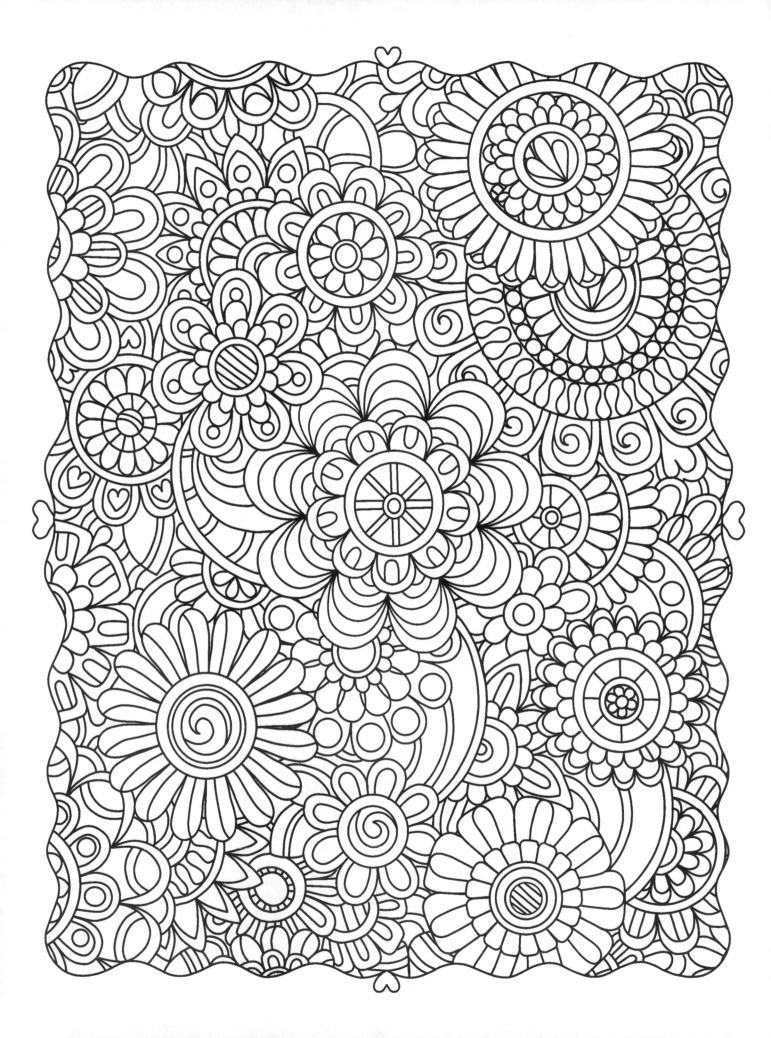

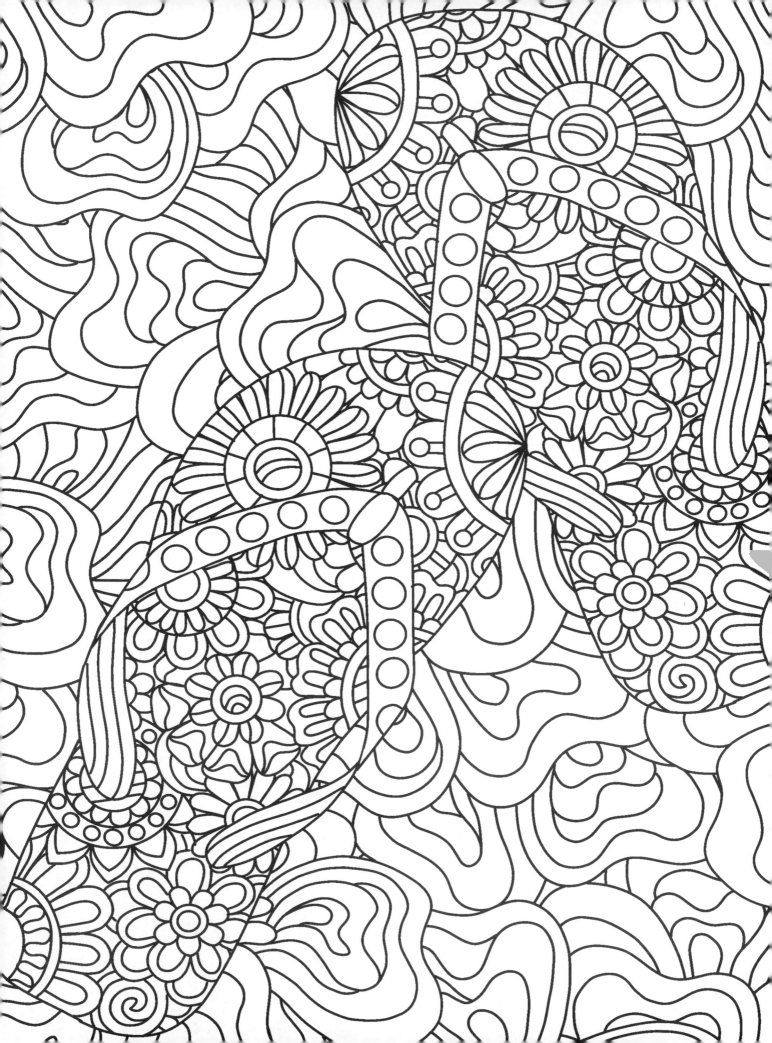

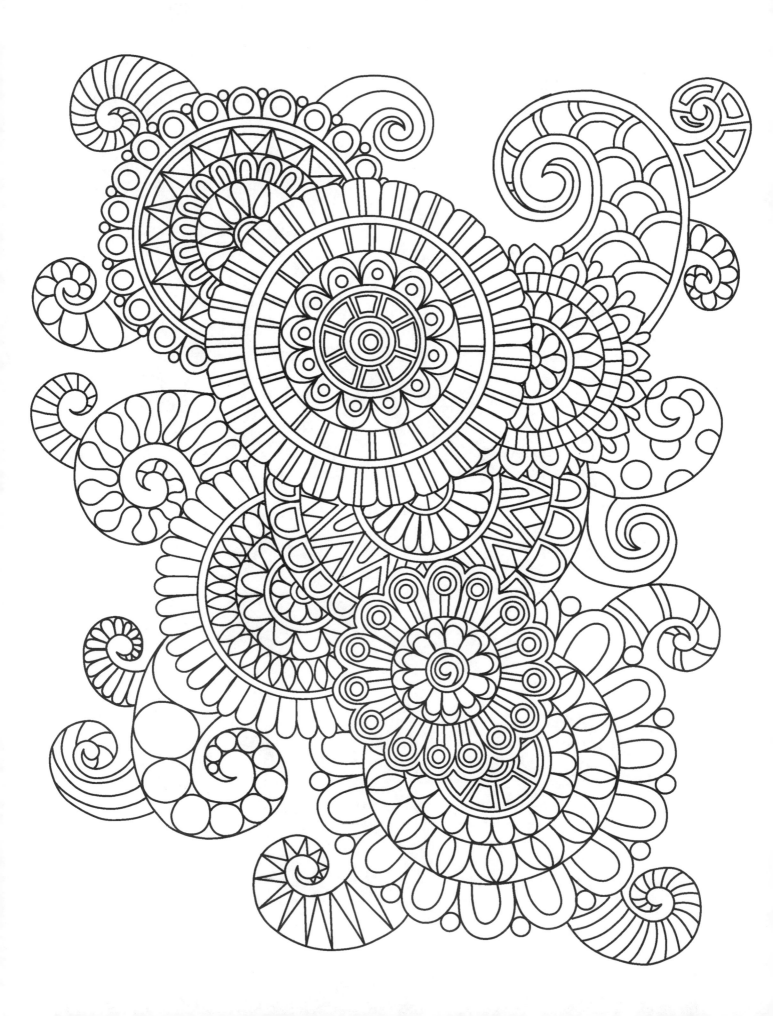

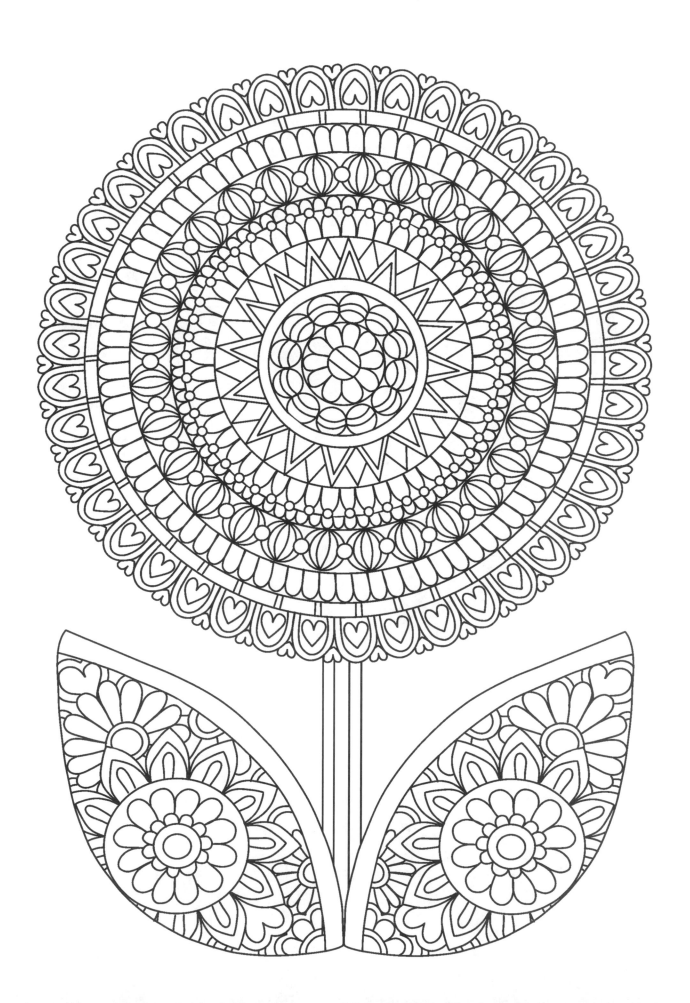

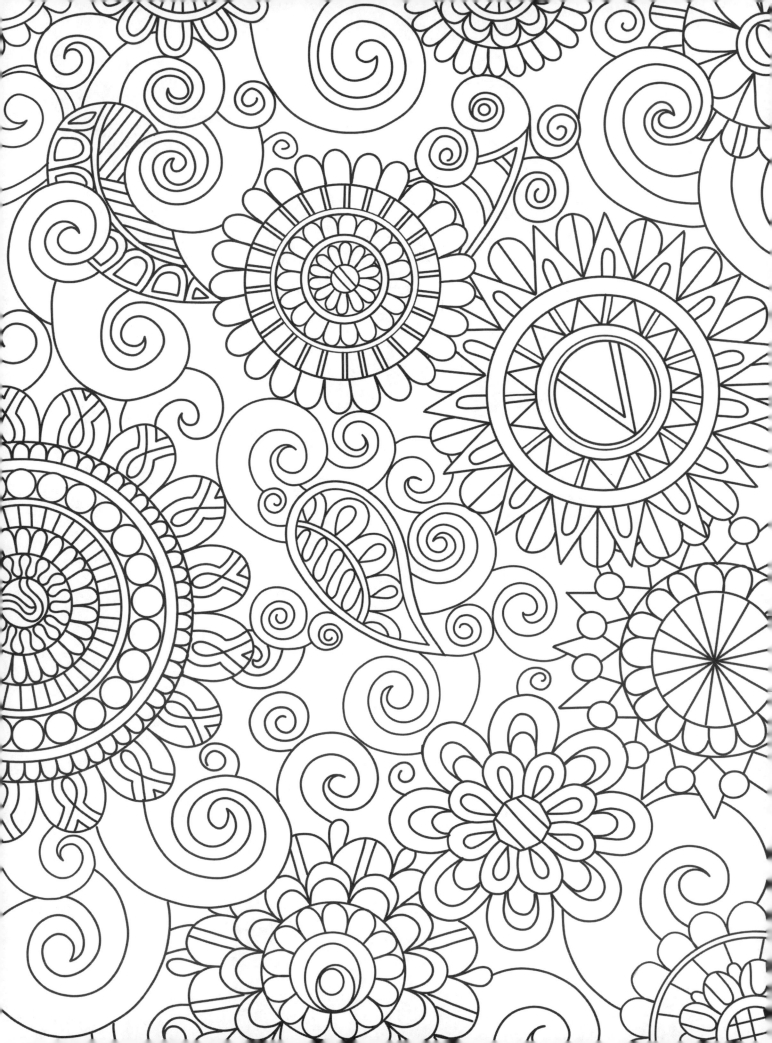

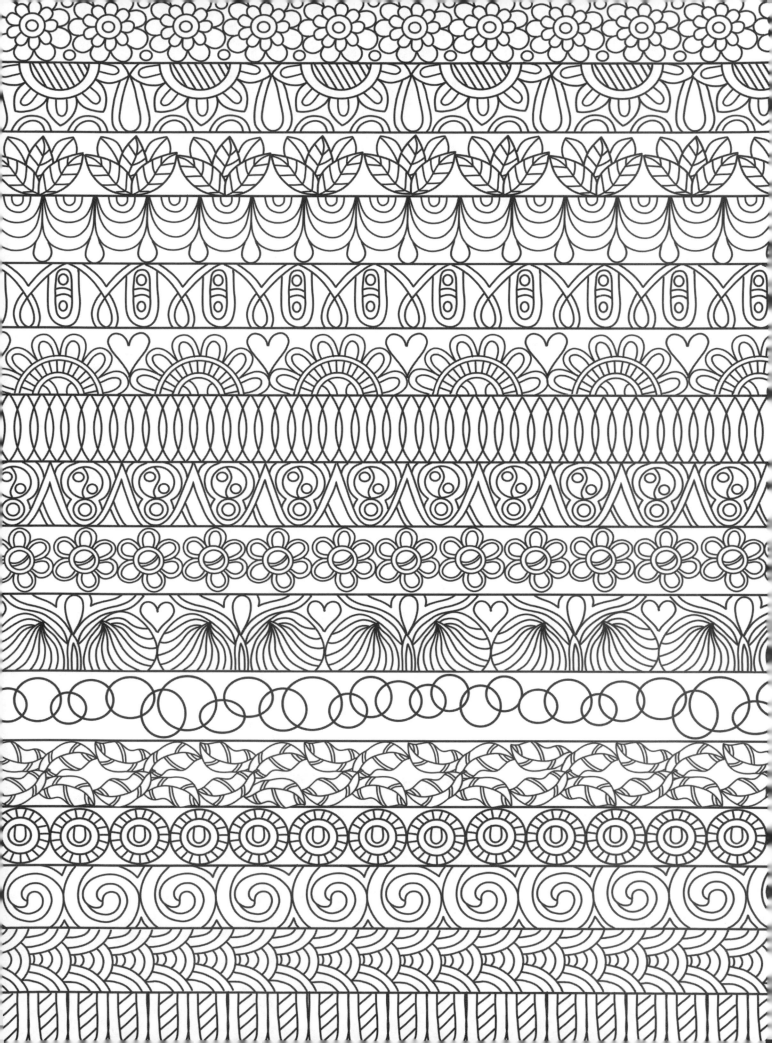

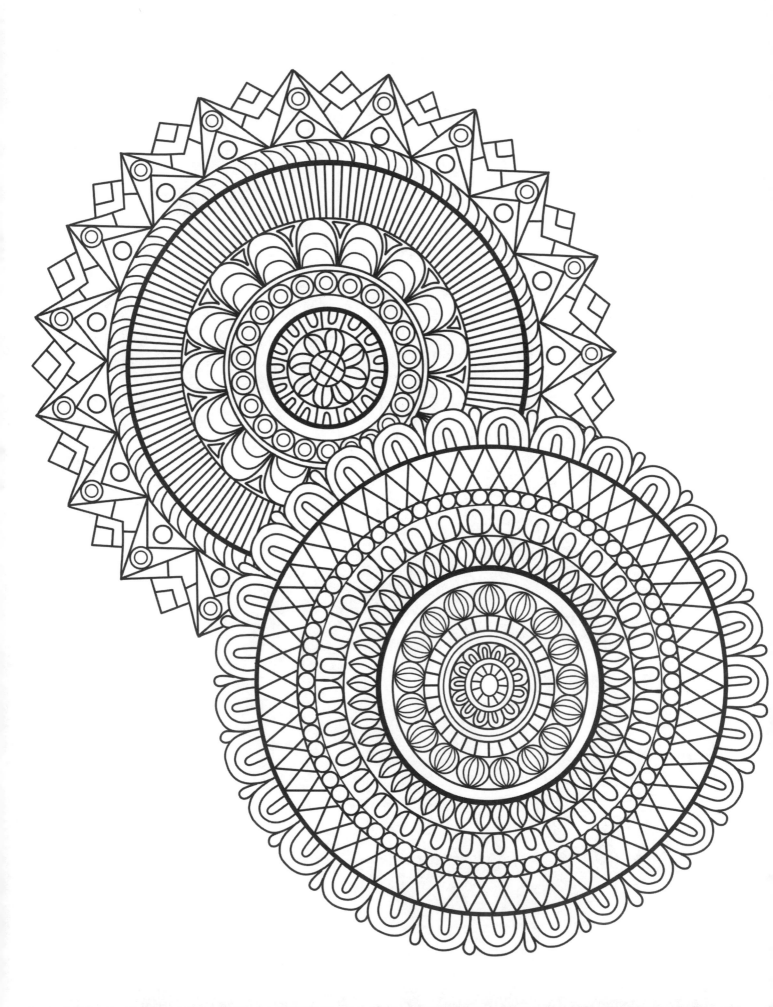

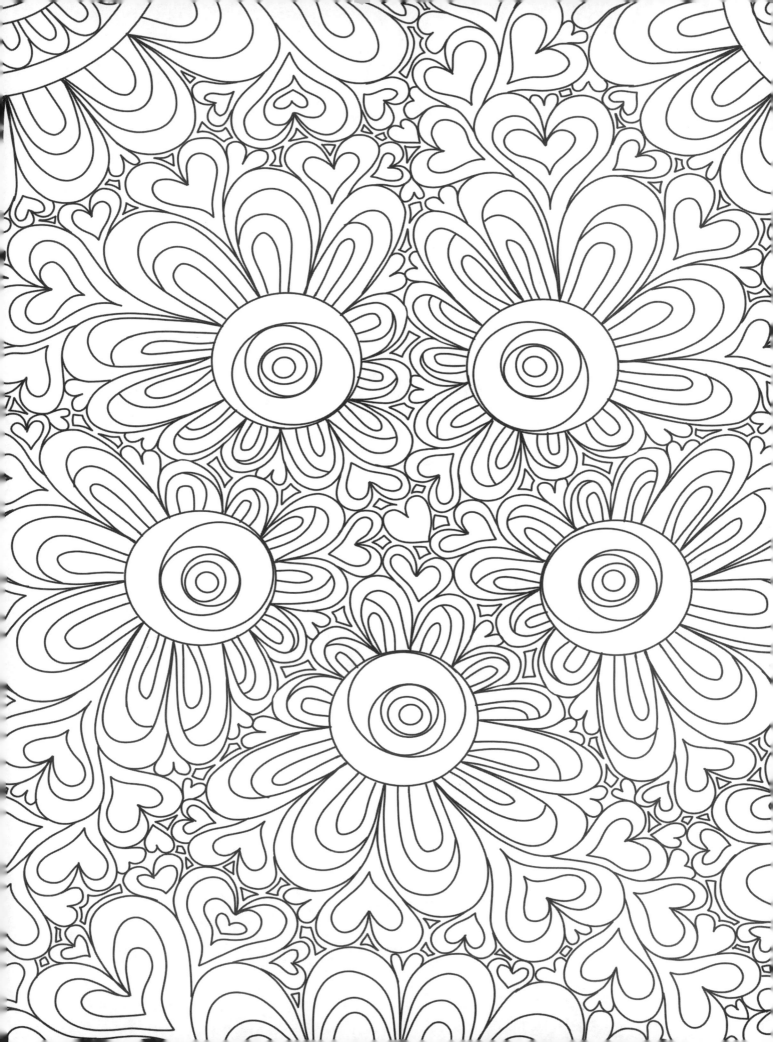

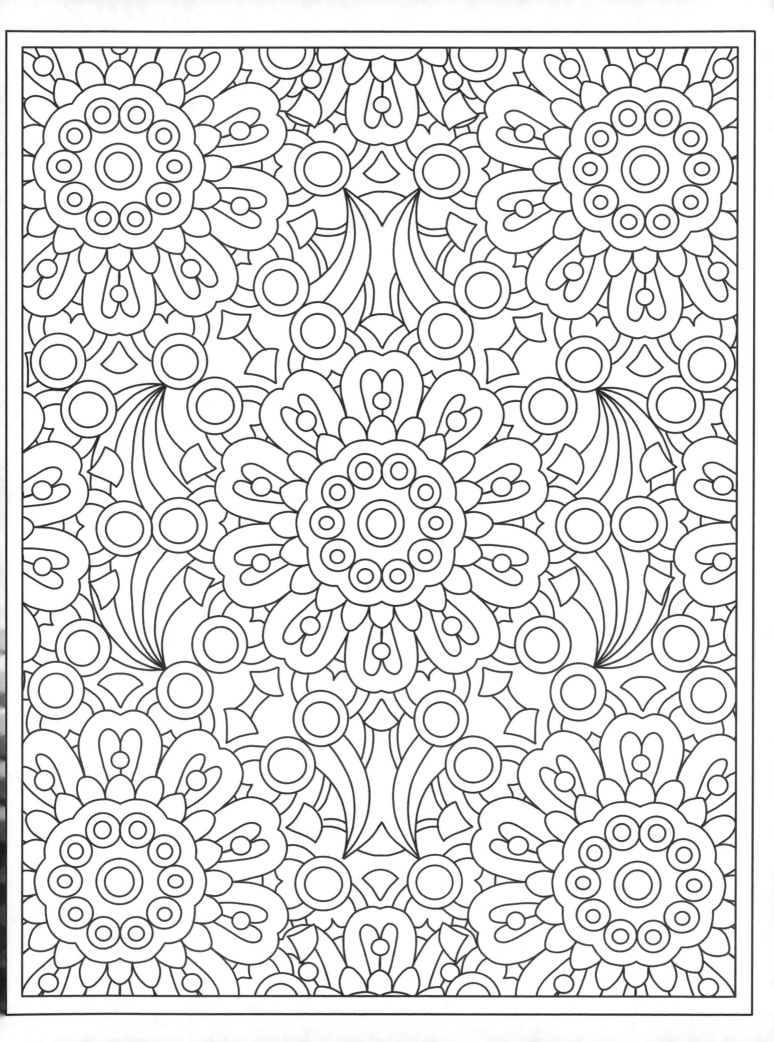

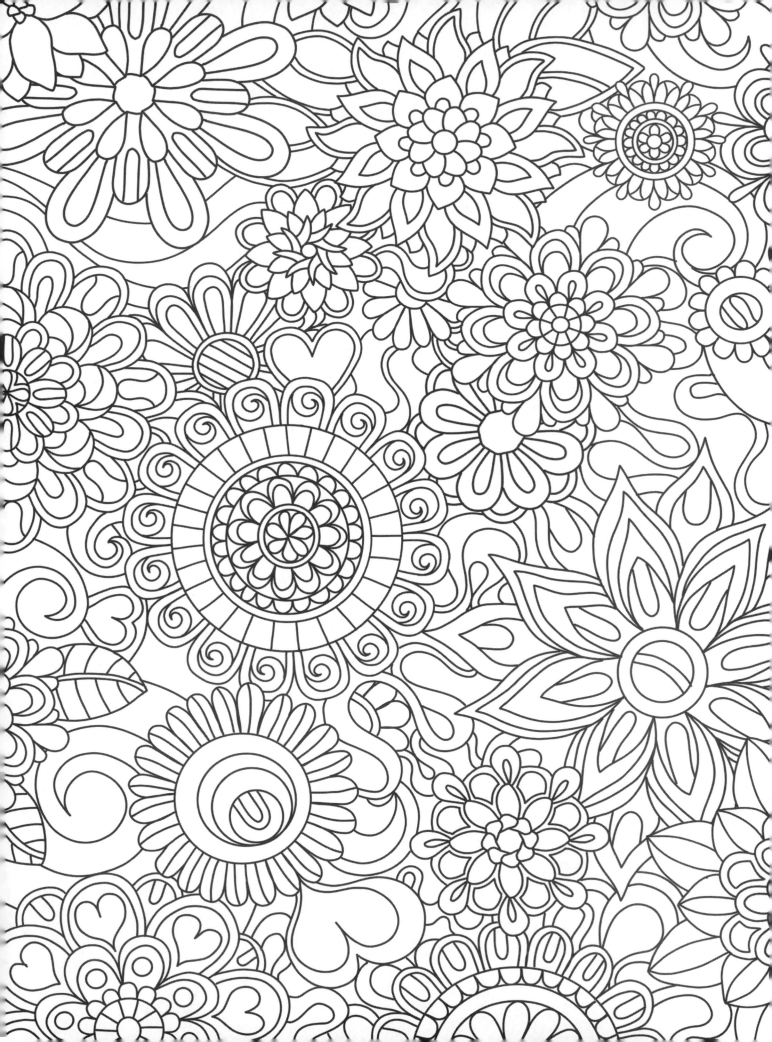

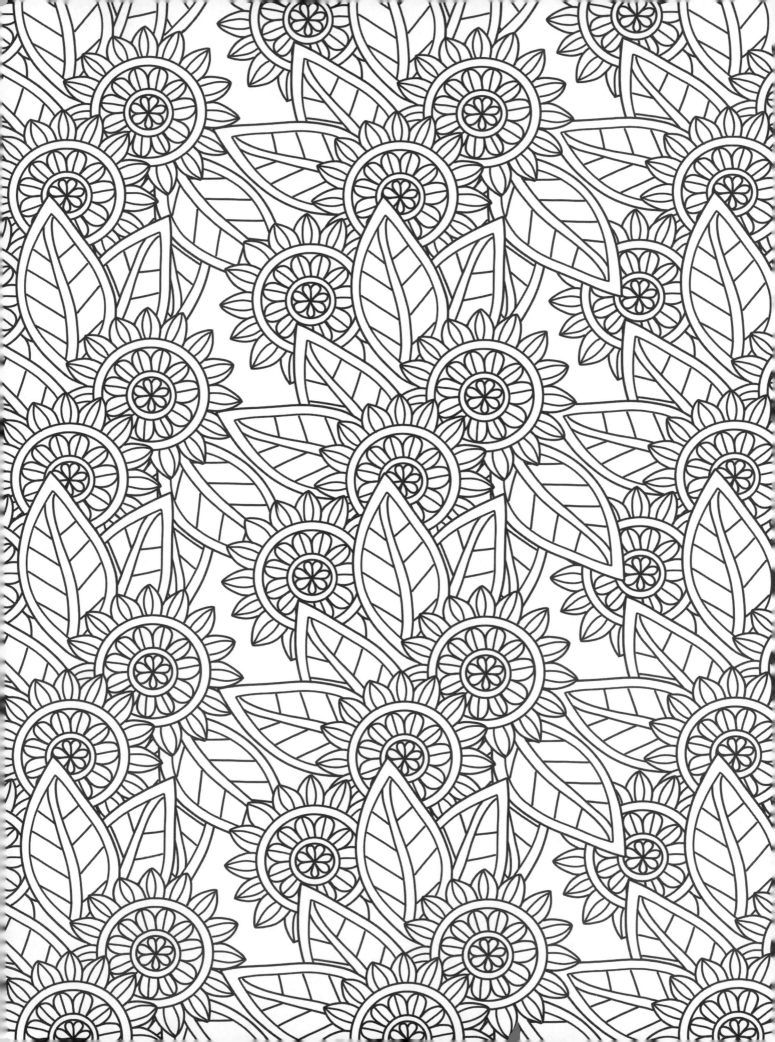

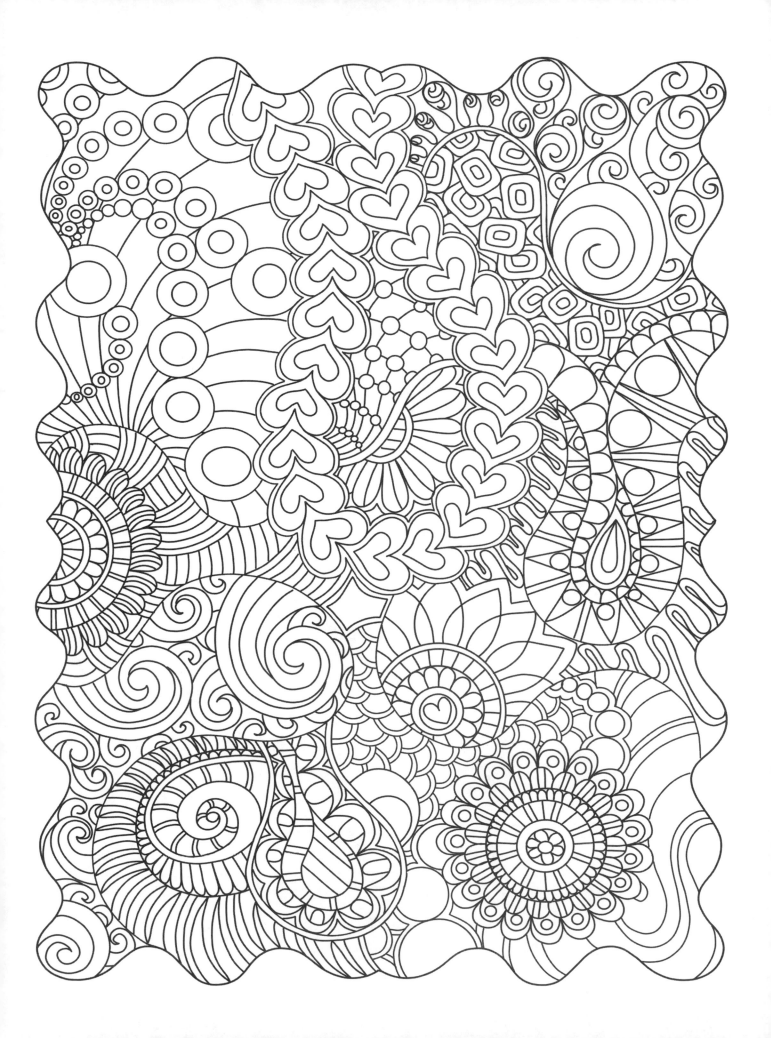

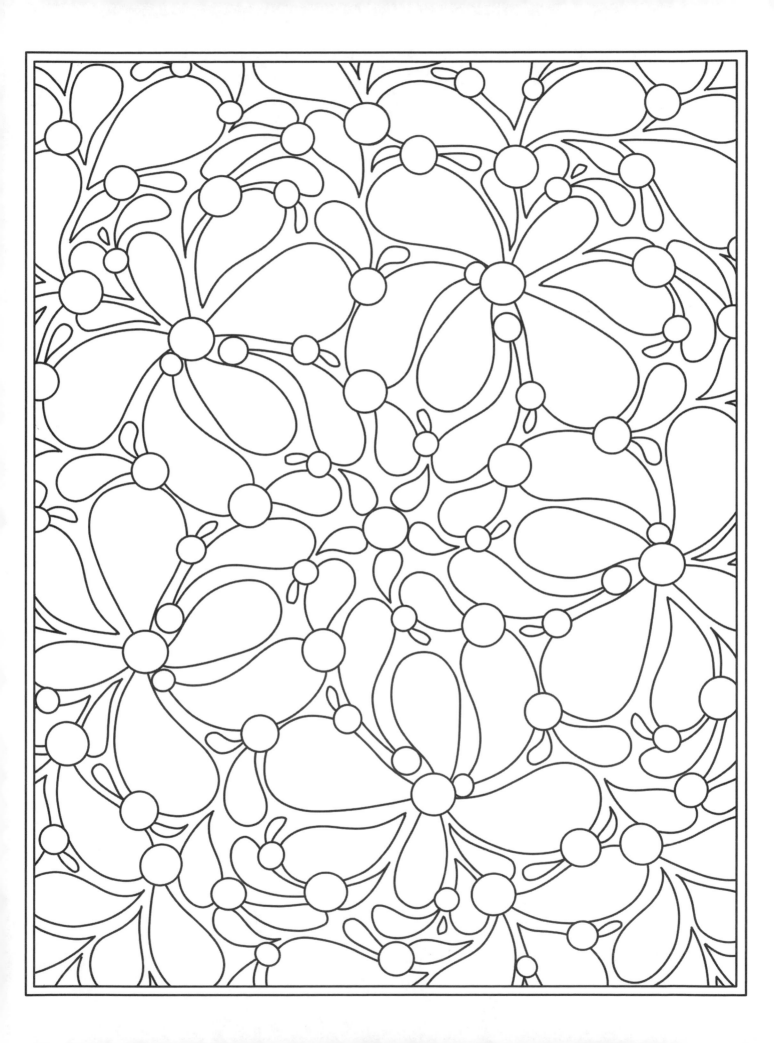

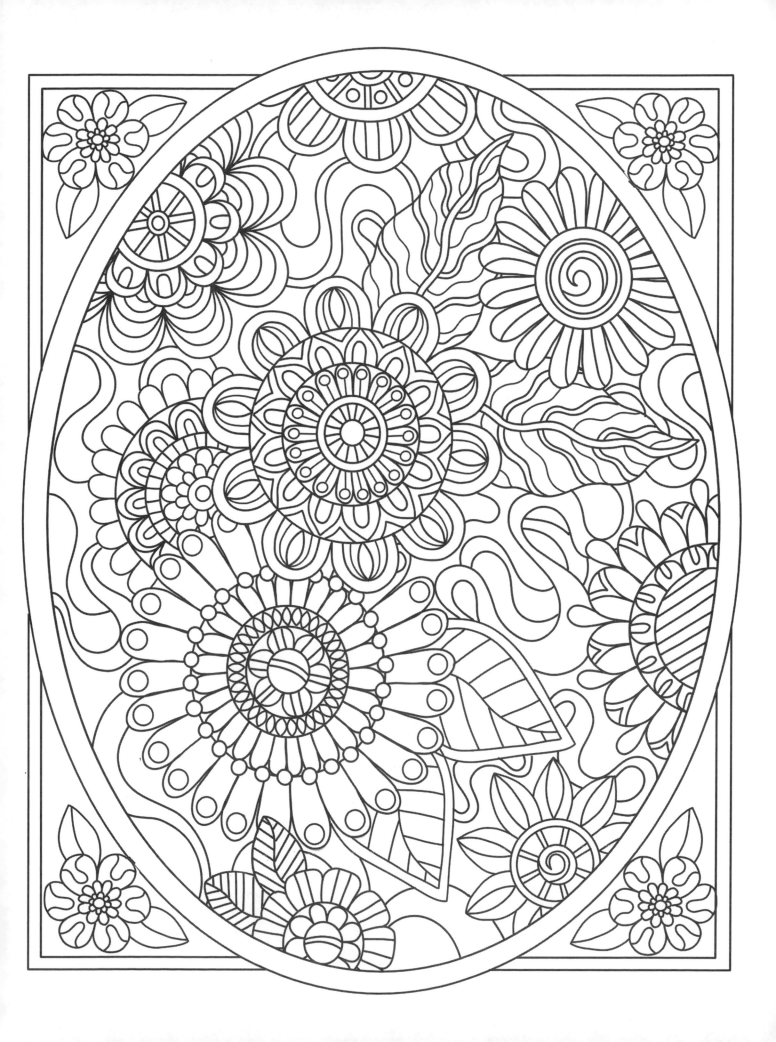

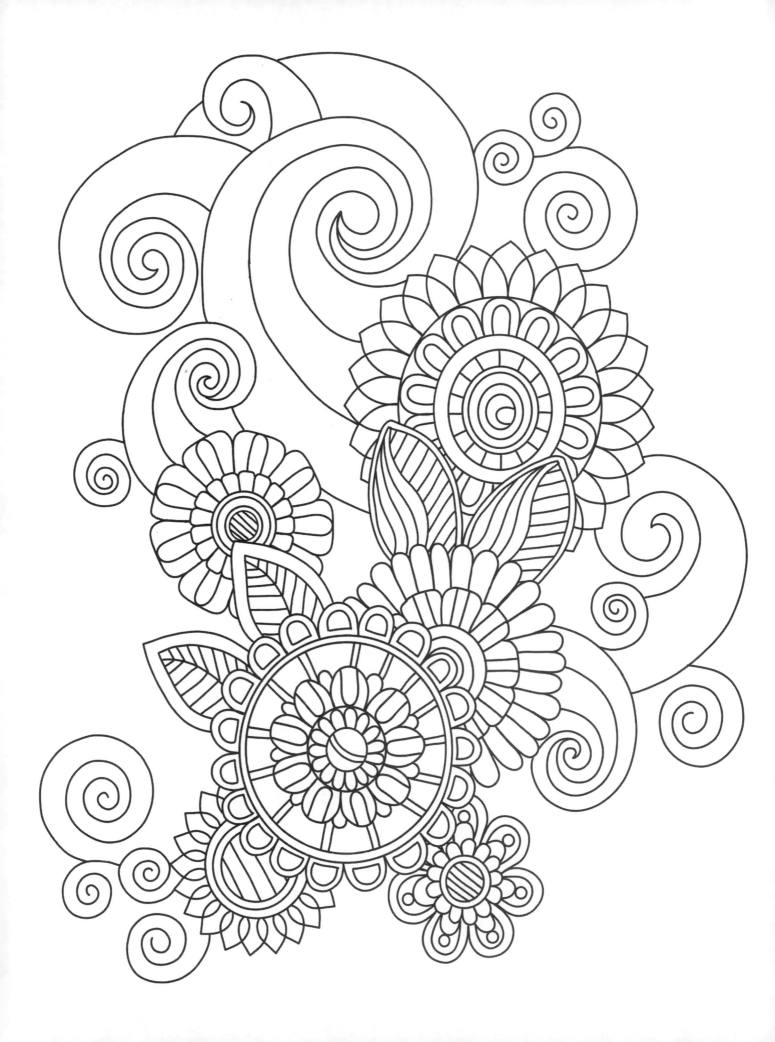

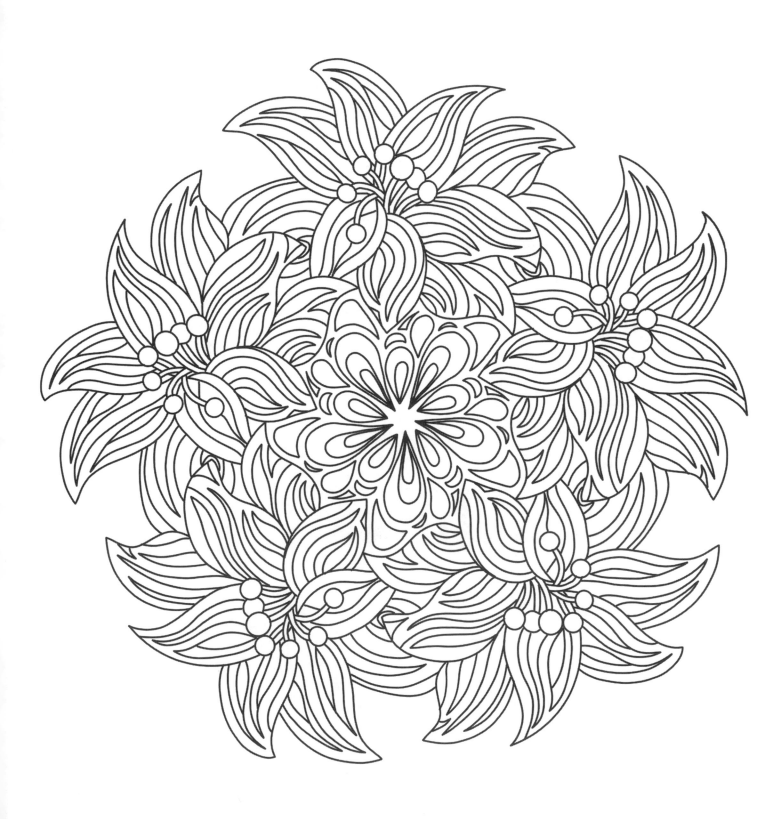

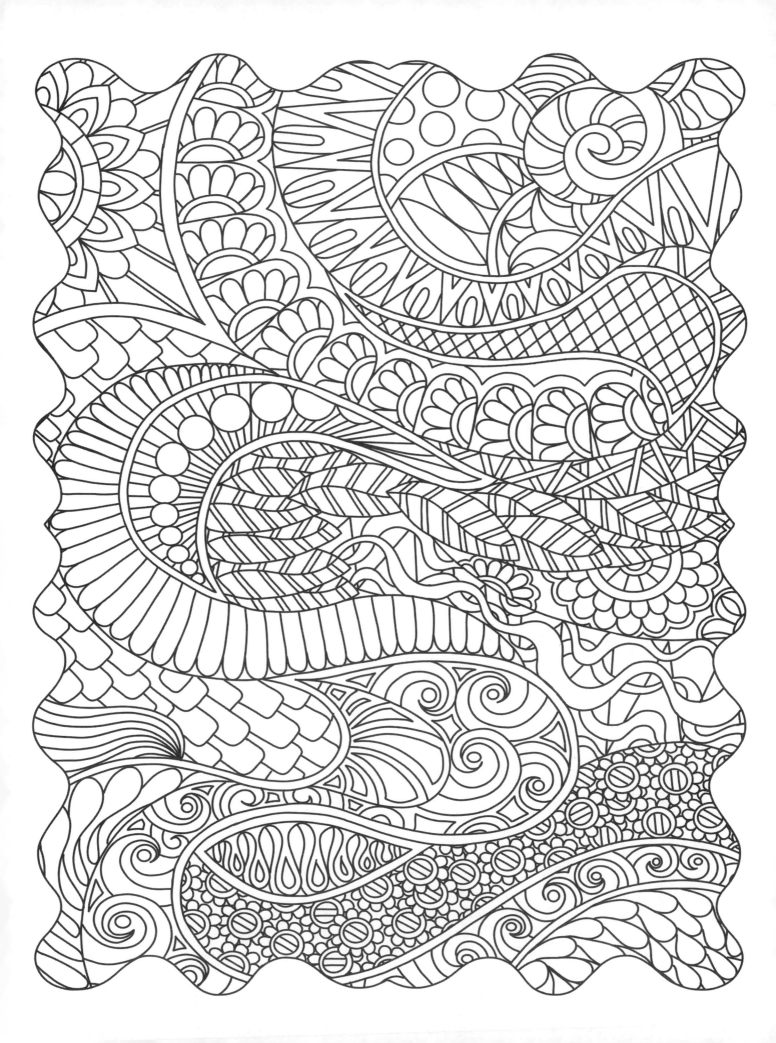

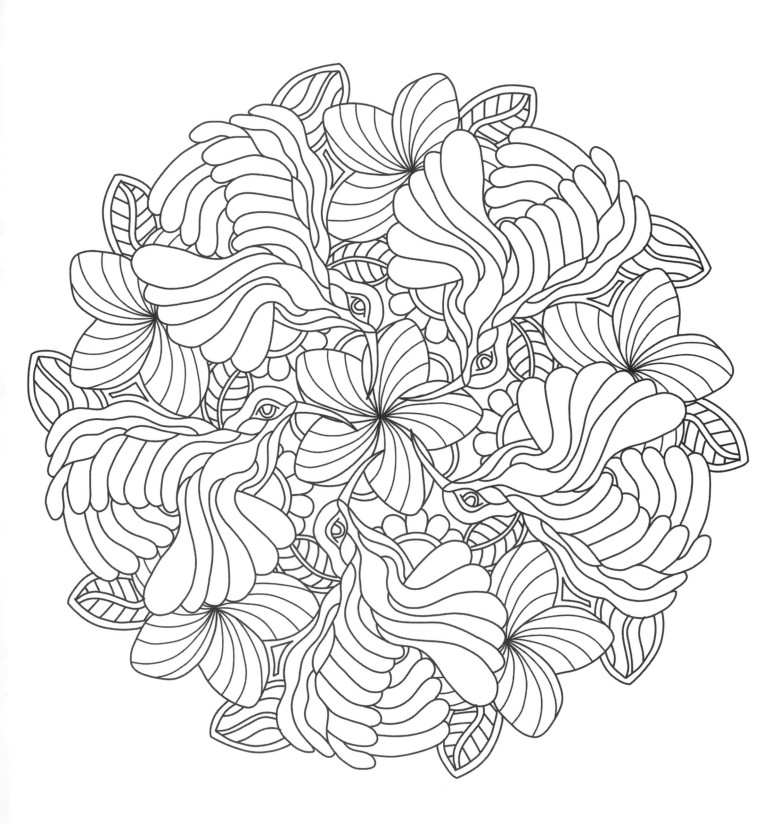

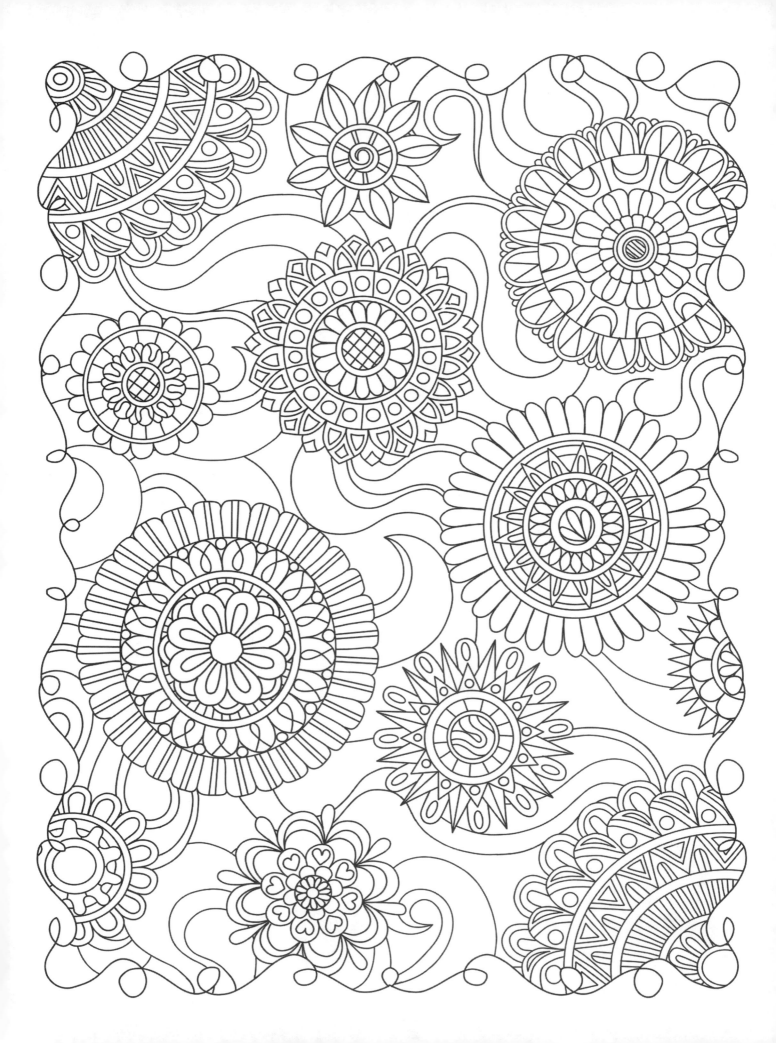

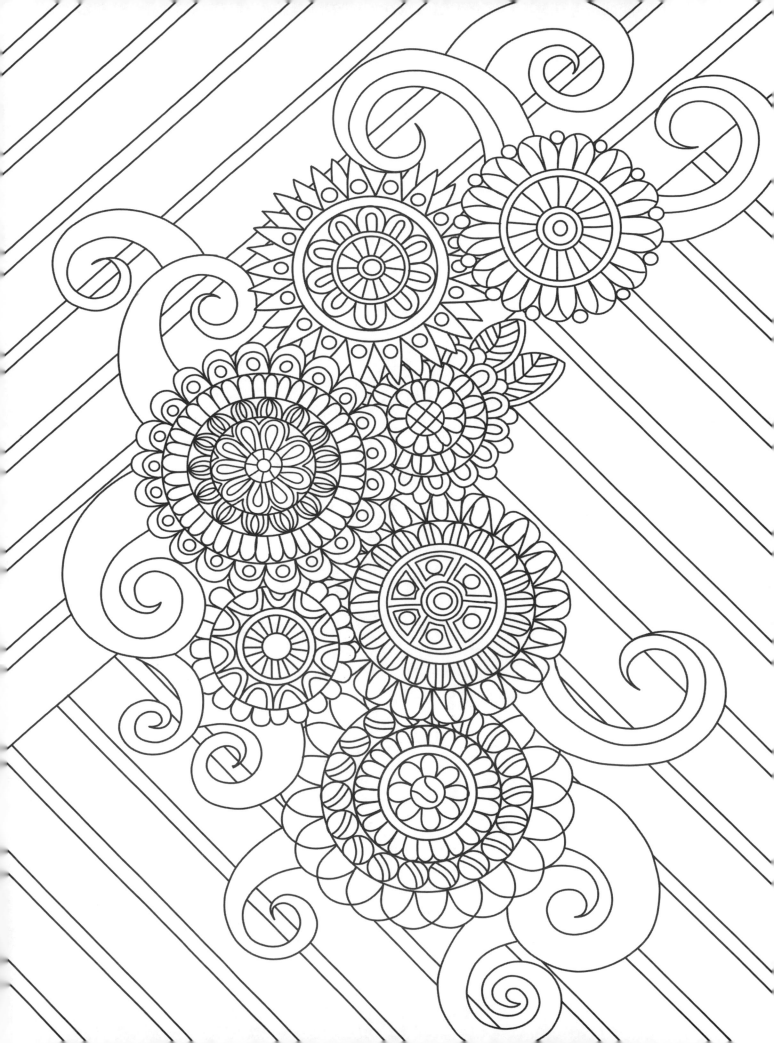

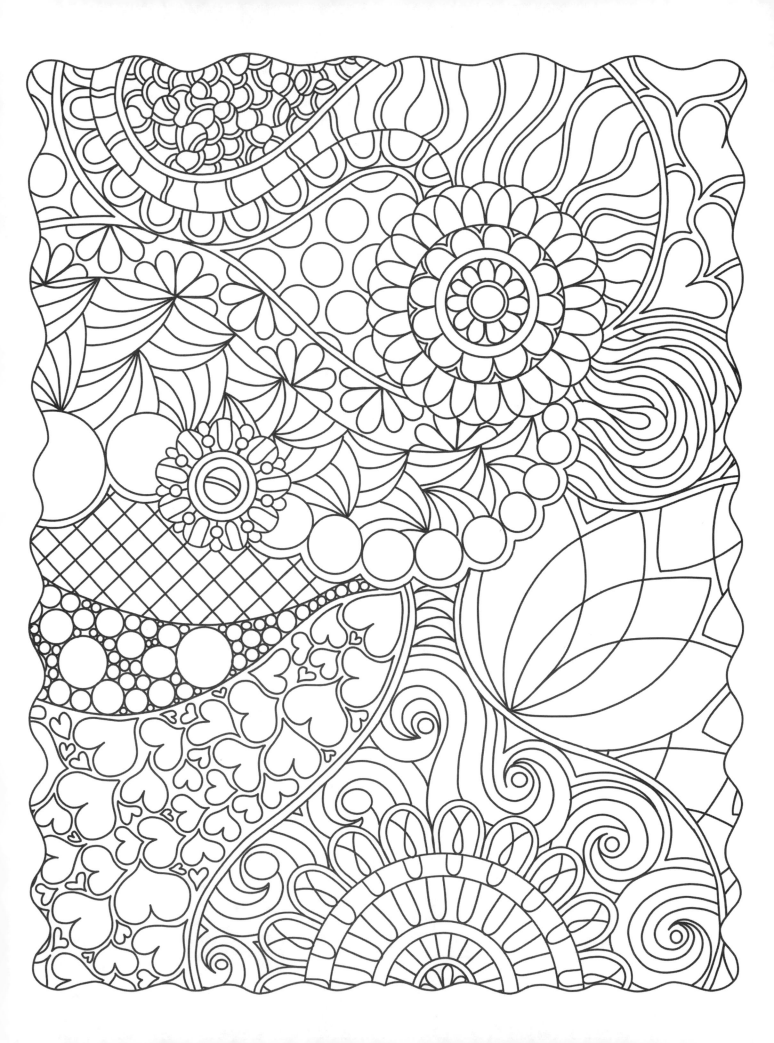

Palette Bars

Use these bars to test your coloring medium and palette. Don't be afraid to try unique color combinations!

Palette Bars

Use these bars to test your coloring medium and palette. Don't be afraid to try unique color combinations!

Palette Bars

Use these bars to test your coloring medium and palette. Don't be afraid to try unique color combinations!

Palette Bars

Use these bars to test your coloring medium and palette. Don't be afraid to try unique color combinations!